THE PHOTOGRAPHER'S WEBSITE MANUAL

How to build and run a photographic website

PHILIP ANDREWS

RotoVision

A RotoVision Book

Published and distributed by RotoVision SA
Route Suisse 9
CH-1295 Mies
Switzerland

RotoVision SA, Sales, Production & Editorial Office
Sheridan House, 112/116A Western Road
Hove, East Sussex BN3 1DD, UK
T: +44 (0)1273 72 72 68
F: +44 (0)1273 72 72 69
ISDN: +44 (0)1273 73 40 46
E: sales@rotovision.com
W: www.rotovision.com

10 9 8 7 6 5 4 3 2

ISBN 2-88046-713-6

Designed by Rebecca Willis at Design Revolution

Production and separations in Singapore
by ProVision Pte. Ltd.
T: +656 334 7720
F: +656 334 7721

THE PHOTOGRAPHER'S WEBSITE MANUAL

How to build and run a photographic website

CONTENTS >

CH1 > WELCOME TO THE WORLD OF THE WEB

CH1>

THE WORLD WIDE WEB

Never before in the history of the world has it been possible to publish your work or promote your business so widely, to such a vast audience, with such comparative ease. Millions of users worldwide have made the Internet the greatest depository of information we have ever known. It has grown way beyond its first tentative text-based stages into a fully interactive and visual experience. It has now become the first place most people turn to when they have a query, want to make a purchase or simply want to communicate with friends and business contacts worldwide.

For photographers around the globe, the Net is proving to be an invaluable tool for furthering their businesses and providing easy access to viewing their images. It is as though a gallery, business office, communication center and marketing association have been wrapped up into one entity, and implanted in your computer on your desktop. Image-making professionals and dedicated amateurs alike are flocking to the Net, realizing the potential of this new tool to further their ideas and boost their companies' bottom lines. It is fast becoming the single most important marketing and business tool of the 21st century. And as such, photographers can no longer ask themselves the question 'Should I have a Web presence?'; instead they need to query 'When will I have one?'.

01> Banners are used to maintain the identity of the pages within your site.

EVERYONE'S A PUBLISHER

When the World Wide Web was in its infancy, becoming an internet publisher meant having to learn about integrated networks, computer protocols, server management and a coding language called HTML. Though not quite 'geek' heaven, the level of understanding and computer literacy needed to produce websites at this time meant that a lot of creative individuals steered clear from the Net.

This complexity meant that the seemingly simple job of creating a site to display your pictures or promote your business required you to engage a graphic design company specializing in Web production. However, with the introduction of a range of visual Web page production tools that create professional-looking, easy-to-use sites, many new millennium photographers are doing it for themselves. In addition, most companies that produce these image-editing packages also include Web-page production features alongside their picture-enhancement tools. Now, with little more than a standard computer, a Web-page program or image-editing software, and a link to the Net, these picture makers are making their presence felt.

This book will guide you step by step through the process of creating your own websites. Using tried-and-true methods drawn from working industry professionals, you will be shown how to take your initial ideas and transform them into fully fledged working Net entities. In the ensuing pages you will learn how to become a worldwide publisher, a position that until recently was jealously maintained by a handful of people who headed up international publishing companies. From your very own desktop, you will be able to capitalize on the potential of reaching the hundreds of millions of people who go online every day.

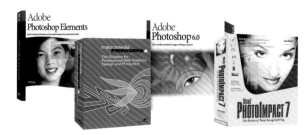

IMAGE EDITING SOFTWARE WITH WEB PRODUCTION FEATURES

WEB PRODUCTION SOFTWARE

 The photographer's website has the potential to become a virtual office, a point of sale, an exhibition space, as well as a center of communication that is open 24 hours a day, seven days a week.

03> It is no longer necessary to be proficient at HTML coding to create your own Web pages. Dedicated Web production packages, as well as most of the leading image-editing programs, provide a visual approach to site design that removes the need to code.

MACHINES WORLDWIDE

Internet

LOCAL MACHINE 1

LOCAL MACHINE 2

local network

LOCAL MACHINE 3

04 > The Internet links computers worldwide, whereas local networks, sometimes called 'intranets', only join the computers in a specific location.

HOW THE WEB WORKS

It is no coincidence that the network of computers worldwide that we have come to know as the Internet, is nicknamed the 'Web'. Unlike the local networks used by big businesses, where each computer or workstation is linked to only those contained within the company, the Internet has the potential to join, and allow communications between, every desktop and laptop machine in the world. Like a spider's web, the Net is made up of many segments and strands. The strength and power of the network is its ability to continue to grow and encompass a wide range of users no matter where they are on our planet.

Each time a new user logs onto the Internet, a new strand of the Web is created. Each of these small strands is a vital part of the World Wide Web community. For all users, the desktop information provided by the Net is interactive and, for some, this communication is two way. Their machines are not only a means to interrogate and find sources of data across the world, but they are also repositories of information that can be shared with other Web users. Those who provide such information are the publishers within this new communications technology.

BEHIND THE PAGES

To most of us, the Web is a sequence of dynamic and graphically rich pages that we view on the screen of our computers. This hasn't always been the case. In the early days of the Net, animations, movies and pictures were not part of the Web experience. A search of your favourite topic would produce countless screens of text-based documents. This is hardly surprising as the Net was initially created as a means for academics from various universities to communicate their ideas and theories. It wasn't long before the potential of a worldwide network linking machines big and small broke free from its

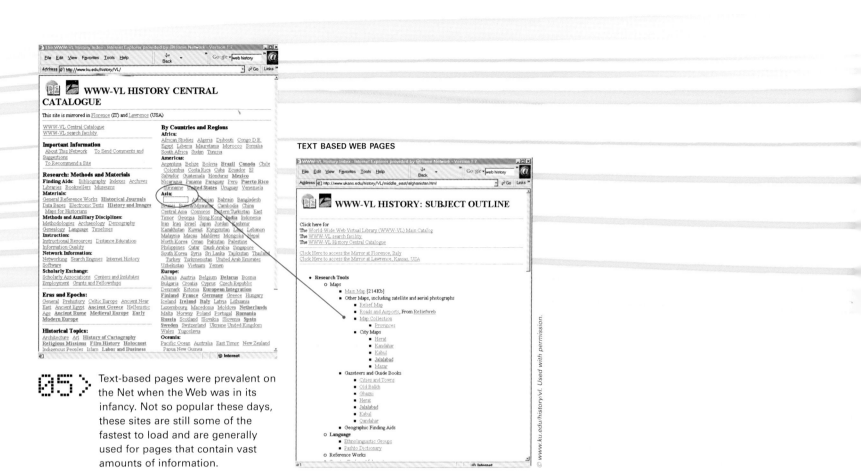

TEXT BASED WEB PAGES

 Text-based pages were prevalent on the Net when the Web was in its infancy. Not so popular these days, these sites are still some of the fastest to load and are generally used for pages that contain vast amounts of information.

academic origins and became a highly graphical and interactive information source that we now know as the Web. Though the face of the Internet has changed from its text origins, the way the pages are constructed has largely remained the same. Behind the pictures and animations is hidden a collection of HTML code, commands and comments that describe the page. This hypertext markup language sits behind every single Web page. Though many changes and additions have been made to HTML during its life as the structure of the Net, the core principal that a simple text file drives the visual front end of all our Web pages has remained the same.

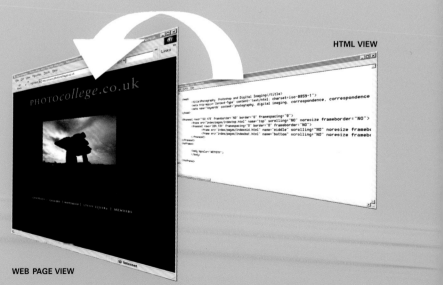

HTML VIEW

WEB PAGE VIEW

06 > Behind the graphical front end of most Web pages are the HTML text or 'source' files that describe the page and its components.

PAGE COMPONENTS AND THE HTML FILE

Most Web pages are made up of a collection of different components. These may include animations, a heading, buttons, some pictures, a little audio, and perhaps a small video clip. When you view the page, each of these components is laid out carefully on the screen together with some body text. It's easy to assume that the page is one gigantic HTML file, but this is generally not the case. Apart from the body text each of these components is stored as a separate file. The HTML code for the page only contains pointers to these files, and a description of where and how they will be displayed on the page.

Each time a page is viewed on a Web browser, the computer scans the HTML text file. At this point, the source files for the different components are located and placed onto the page ready for viewing. For those of you who are familiar with word processing documents where all the various elements such as text, tables and graphics are stored in the one file, this way of working might seem a little strange. The important thing to remember is that most Web pages are made up of the main HTML file as well as a collection of other component files.

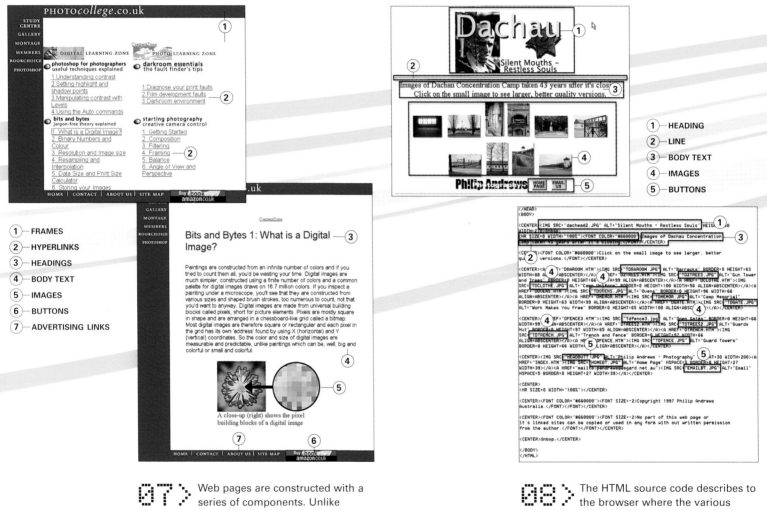

07> Web pages are constructed with a series of components. Unlike word-processed documents, all of these components (except the body text) are stored in separate files.

08> The HTML source code describes to the browser where the various component files are and how they should be laid out on the Web page.

As always there is an exception to the rule. Pages and websites that are made with the Flash file format (.SWF) incorporate all visual and text components together into one main file. Despite being presented in an HTML page environment, the Flash file format is capable of supporting incredibly dynamic and visually exciting websites, whose inner workings are not based on the text HTML file. A lot of Web commentators see the Flash format as the way of the future for design-based sites that offer graphically rich Internet experiences for Web audiences (see fig 09). For the moment though, these sites still have to sit within a framework that is predominantly HTML-based.

© www.conclaviobscuri.ru.
Used with permission.

© www.garciastudio.com. Used with permission.

09 > The Flash file format departs from the traditional HTML page description approach and is used to produce highly creative and visually rich Websites.

CH2> PHOTOGRAPHIC SITES AND WEB PAGE CREATIONS

CH2> BEFORE YOU START

Despite the fact that the Web is fairly new to our experience, Internet technology is essentially concerned with an activity that is far older – communication. For image makers, this means the passing on of ideas through their pictures and the setting up of business scenarios between customers and suppliers. And, like any form of communication, one of the first steps you should undertake when creating a website is to be clear about what you are trying to say, and to whom you are trying to say it.

Your site may well be the first contact that you have with potential customers or members of a viewing audience. For this reason, just as much care should be taken when designing and presenting this contact point as you would when preparing images for an exhibition. Viewers must be presented with a clear and easy to understand Web-based statement of your ideas.

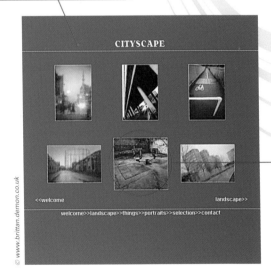

01> One of the most popular types of sites with photographers is the virtual gallery. Here image-makers can show off their greatest pictures to a worldwide audience.

PURPOSE AND AUDIENCE

Put simply, for communication to occur, you must be clear about the purpose of your site. Your site may have one overall reason for being, or it could combine several ideas into a multipurpose entity or Web portal. Deciding the purpose of your site early on in the design process will help to ensure that the results of your hard labor will be communicated clearly to those who view your pages.

Whilst you are contemplating the make-up of your site, you should also consider who your audience will be as this will, in part, determine how your pages look and what they contain. The most successful sites, just like other forms of good communication, are the ones created with a definite audience in mind.

So despite your desires to 'get stuck into' the making of your website, take a little time to consider the purpose and audience of the site first. Being clear in your own mind about these two factors will make a huge difference to how effectively your Web work communicates.

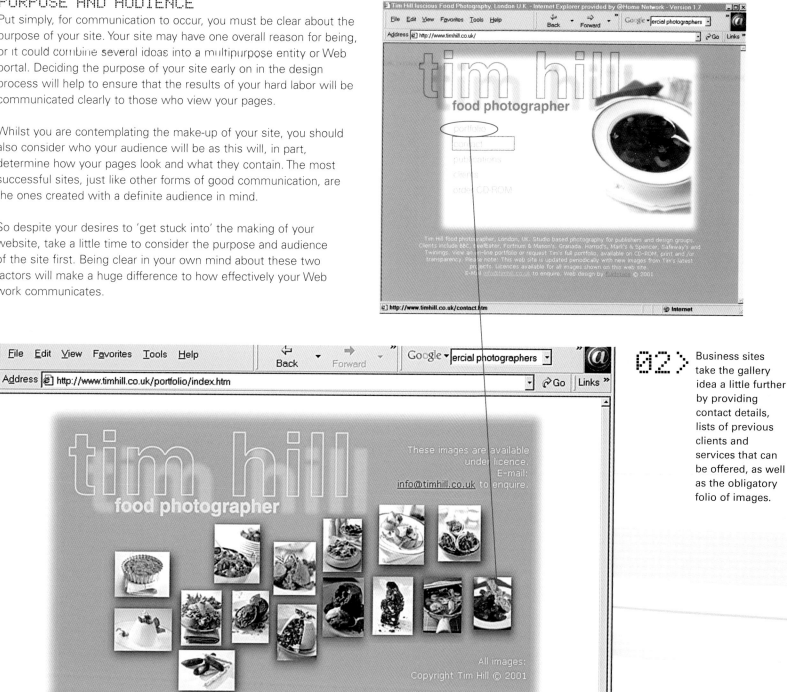

02 > Business sites take the gallery idea a little further by providing contact details, lists of previous clients and services that can be offered, as well as the obligatory folio of images.

THE PROCESS

Planning

There are five distinct stages of the website production process. The first stage is the planning phase. It is here that the general visual concept for the site is first formed. Having already thought about the audience and purpose of the site, it is now time to draft how the content is to be laid out.

As we have seen, most websites are constructed from a range of different components; these are generally called the Web assets. As part of the planning stage, the site's content is divided into its different asset categories. Decisions about the requirements or specifications of each of the content types are then made.

For photographic sites, these decisions will be generally centered on the size and quality of the visuals used. It might seem a little premature to be thinking about such technical issues at this point, but the creation of a visually rich site that also downloads quickly is no accident File size and picture quality always need to be balanced against display time.

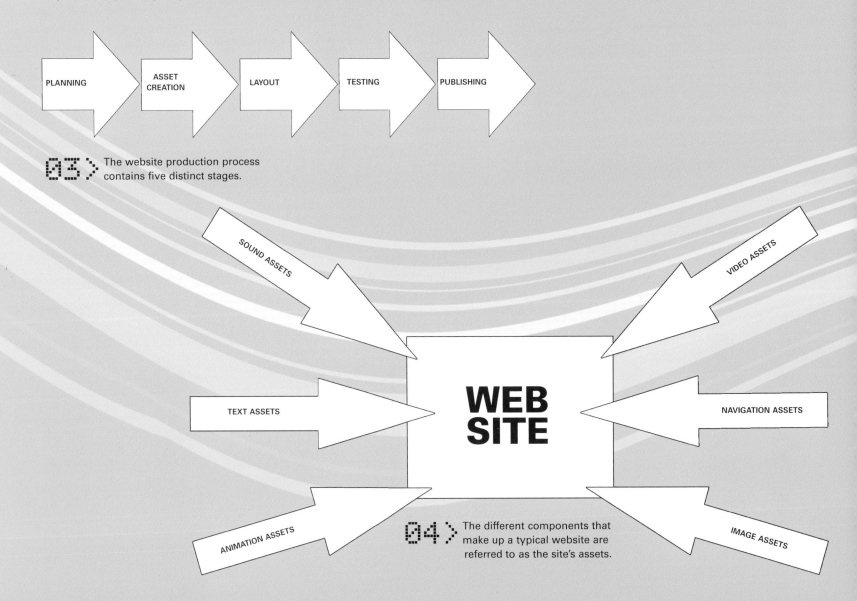

03 > The website production process contains five distinct stages.

04 > The different components that make up a typical website are referred to as the site's assets.

Asset creation

The next step in the process is the asset creation phase. In a large organization, this would mean delegating different aspects of the site's production to various specialist content creators, but for the photographer creating his or her first site, it is a case of being a 'Jack' or 'Jill' of all trades. Luckily, most quality image-editing packages contain simple-to-use tools that produce headings, buttons, rollovers and Web-ready photographs quickly and relatively easily.

PHOTOSHOP'S 'SAVE FOR WEB' FEATURE

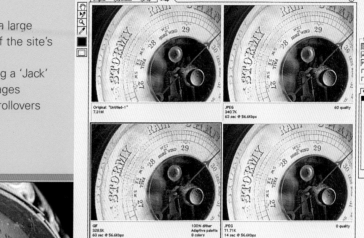

PHOTOIMPACT'S SEAMLESS TILE FEATURE

05 > A lot of the major image-editing packages (both professional and entry level) currently on the market contain special features specifically used for the production of Web assets.

PAINTSHOP PRO'S IMAGE SLICER

Page and site layout

Bringing together all the assets into a single well-organised, well laid-out and, most importantly, fully functional website occurs within a software package generally referred to as a page-layout or Web-design program. These packages allow the photographer to combine all the major components into one visual form.

In the early days of Web work, the programs looked and functioned like basic word processors. Designers needed to have a good understanding of the HTML language to be able to construct sites. Thank goodness that the clever software-manufacturing companies now provide us with Web-layout tools, which are WYSIWYG (What You See Is What You Get). Designers can now lay out the components of pages in much the same fashion as they do when creating layout spreads for a magazine using page-layout software.

In addition to the dedicated packages, many image-editing programs contain Web-page creation features. Though generally not as flexible as the specialist programs, these Web options provide a quick and painless way for photographers to create their first site.

06 > HTML editors are used to put together pages based on the source code that exists behind the visual front end.

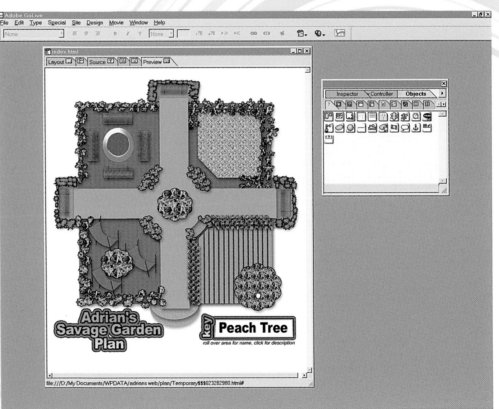

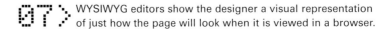

07 > WYSIWYG editors show the designer a visual representation of just how the page will look when it is viewed in a browser.

Testing

The testing phase of the production process is often overlooked but its importance cannot be overstated. It is here that the results of the planning, asset-creation and layout stages are assessed and, if need be, adjusted. The testing process is made easier because most modern website-construction programs contain built-in testing features. Most are able to emulate different working platforms and contain preview features that show the site in a variety of browsers. In addition to this type of local testing, it is critical that a draft version of the site be placed on the Net so that factors like download time are not just estimated, but are based in reality.

 08 > The popularity of the Internet amongst photographers has meant that mainstream image-editing packages like Photoshop and Photoshop Elements contain easy-to-use Web page wizards designed to guide the users through the production process step by step.

09 > Most Web-production packages can preview your pages in a variety of browsers as you design them.

Publishing

Publishing, the last stage in the process, occurs when the finalized site is released to the public. Here the site's files are uploaded to a computer permanently connected to the Internet called a Web server. The transfer of files is usually handled by a FTP (File Transfer Protocol) program. This small utility program links the Web server with the machine sitting on your desktop.

This point marks the culmination of all your hard work and, unlike in Kevin Costner movies about baseball, just because you have 'built it' doesn't mean that 'they will come'. It is just as important to advertize and draw attention to a new website, as it is to publicize other information products. Printing your Web address along with your normal contact details on letterhead, invoices and emails will help others become aware of your Web presence. Saving specific Metatags that describe the contents of your site in the heading section of your pages, will help Web search engines provide discriminating information about your site and direct customers to your virtual front door.

10> A FTP (File Transfer Protocol) utility links your machine with a computer that is permanently connected to the Net.

11> Metatags are a series of words that describe your site and its content. These tags are included in your HTML file but do not show up when your page is viewed.

DESIGN AND LAYOUT ISSUES

One of the biggest problems facing the Web publisher is the fact that the various machines used to view the pages created can be totally different for each member of their audience. For this reason, most Web designers understand that it is necessary to ensure that the pages created can be viewed on Macintosh, Windows and UNIX computers. Care should also be taken so that the site works with several different types of browsers as well as different versions of each browser.

With this in mind, the major software manufacturers have added preview features to their image-editing and page-layout programs. With the latest releases, it is possible to preview your Web pages in different versions of all the major browsers. This means that the designer can install a variety of the most popular browsers and browser versions onto their computer, and use these to ensure that their design remains visually the same for all viewers. An extra feature of some packages allows the designer to simulate the environment of different computer platforms right from their desktop.

12> It is important to preview Web pages on a variety of browser types and versions. Small differences in the way each program displays your pages may create big problems for your audience if left unchecked.

Original: "07290064.JPG"
92.2K

13> Other preview options allow the Web designer the chance to preview their work as it will appear on a different computer platform.

INFORMATION VERSUS DESIGN-BASED SITES

It is important not to lose site of the fact that Web design, like most other forms of design, is about making sure that the product fits with audience requirements. A quick scan of an assortment of Web pages will show a range of solutions used by designers to ensure that the way that they present information suits their target audiences. You should immediately notice that there are at least two distinct groups of website designs: those whose primary function is to present as much information as succinctly as possible, and those containing sites whose role it is to provide a rich audiovisual experience.

Different design approaches are necessary for the production of these two very different, types of sites. The major software packages also tend to align themselves with each of these directions. Some provide built-in features like 'live linking' to back-end database files that ensure that their product is well suited for the production of information sites. Other manufacturers provide a highly visual work environment that suits the production of design-orientated sites.

Photographers, being highly aesthetic people, tend to produce design-based sites concentrating on the display of quality visuals. Information, when it is included, is usually in the form of client lists or contact details. Sites for photographic businesses and associations, though still wanting to provide highly visual front ends, do contain substantially more text-based information. As well as the mix of these two design styles, photographic sites generally fall into one of the categories described in the following paragraphs.

PHOTOGRAPHIC SITE TYPES

Galleries – Based on a traditional concept, these sites are designed for the exhibition and sale of artworks. Generally, gallery sites provide information about the photographer as well as the images and some even have the ability to make print purchases online.

Shop fronts – The Web has provided an unequalled opportunity for photographic retailers to connect with their customers. Unlike traditional storefronts, a virtual shop is open all hours and doesn't have a potential client base that is restricted to the immediate location of the store. As with the gallery, a lot of sites provide the opportunity to purchase online.

© John Paul Caponigro, Caponigro Arts, LLC

1.4 > Most sites are either information- or design-based. As photographers are visual people, they tend to produce design-based sites even when they offer a host of information.

Libraries – Libraries, or reference sites, give users the chance to research all manner of photographic topics online. Working in much the same way as a traditional library, some sites provide Internet-search facilities for traditional references such as books and magazines, others provide a full digital service supplying both the search engine and final document electronically to your desktop. Hardware and software manufacturers often provide vast amounts of information about their products in this way.

Folios or Stock Libraries – Ranging from a virtual folio produced by a solo photographer to the massive online image databases run by

the big stock agencies, these sites have one job only – to get images seen. When putting together this type of site, the emphasis should be to make sure that images can be found easily and that they are shown with enough detail so that prospective clients can get to see the quality of the pictures.

Associations – Sites in this group are basically the Web presence of industry associations or collections of individuals with similar interests. Their features often include information sections used for discussion of current industry issues, downloadable resources and links to other sites containing similar content.

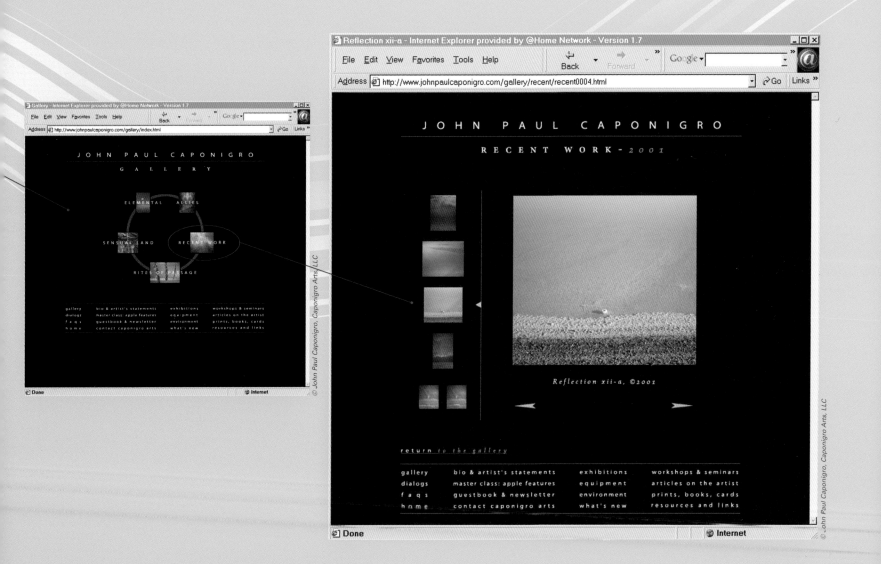

NAVIGATION DESIGN

A major part of your site's design is concerned with how users will move from one page to another. The standard solution is to provide a series of buttons, tabs or arrows created for the purpose. The positioning and look of these movement devices is usually referred to as the navigational design of the site.

A lot of Web design is based on providing a consistent look and feel to a site so that the viewer, moving from one page to another, has a general understanding of where they are and where they are going. This means that the navigation system has to be unified in its approach to moving between pages and sections of the site. At the very least, navigation buttons should be positioned in the same place on each page and, more generally, they should reflect the thematic and aesthetic ideas that underpin the rest of the site.

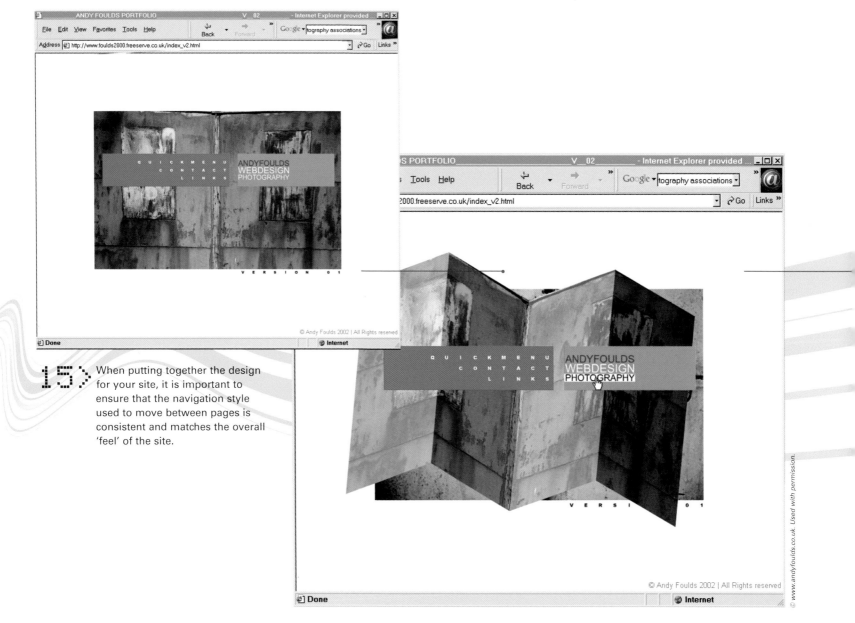

15> When putting together the design for your site, it is important to ensure that the navigation style used to move between pages is consistent and matches the overall 'feel' of the site.

For instance, if the pages have a 'jungle' feel, then it might be appropriate to use animal icons for the button fronts of the navigation devices. If, in a different part of the site, the animal icon buttons are changed to geometric arrows and stylized words, then the overall design lacks consistency and the viewer is apt to lose their way.

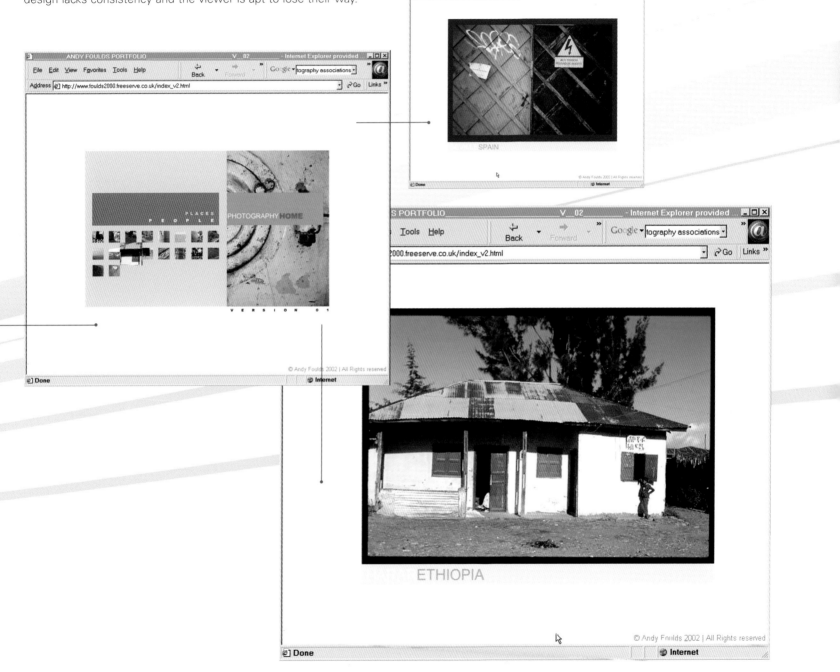

Apart from these thematic concerns, the structure and sequencing of pages also needs to be logical. Viewers need to be aware of exactly where they are within the site at all times. They also need to be able to move to any part of the site with very few button clicks. To help with this, designers often provide a site map as a reference to the major sections and pages contained within a Web space. The site map overview allows the audience to get a good mental picture of how the site is constructed and how best to find the information needed.

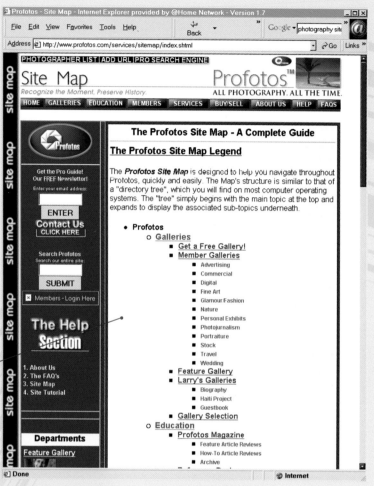

1.6> Site maps are a great addition to the navigation design of your site. They provide an overview of all the pages and content areas of your site.

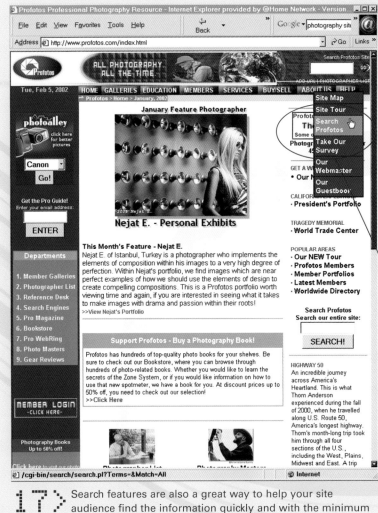

In addition to a site map, a lot of Websites contain search buttons. This feature can cut down the amount of time needed to locate specific information within a large or complex group of pages.

It should be your aim to create a series of well-designed pages that are easy to navigate and where the information is presented in a way that seems natural and logical to the user.

17› Search features are also a great way to help your site audience find the information quickly and with the minimum amount of mouse clicks.

Profotos Site Search

Profotos > Site Search Engine

Pro Search Form	Match All
	Search

Search Rules

This search engine helps you find documents on the Profotos website. Here's how it works: you tell the search service what you're looking for by typing in keywords, phrases, or questions in the search box. The search service responds by giving you a list of all the Web pages on our site relating to those topics. The most relevant content will appear at the top of your results.

How To Use:

1. Type your keywords in the search box.
2. Press the Search button to start your search.

Here's an example:

1. Type **advertising photographers** in the search box.
2. Press the Search button or press the Enter key.
3. The Results page will show you numerous pages on Profotos which include the term "Advertising Photographers"

Tip: Don't worry if you find a large number of results. In fact, use more than a couple of words when searching. Even though the number of results will be large, the most relevant content will always appear at the top of the result pages.

More Basics - An Overview

Here's a quick overview of the rest of our Basic Help. Just click on the links to

CH3> THE SOFTWARE OPTIONS

> ASSET-CREATION PACKAGES

> PAGE-LAYOUT PACKAGES

> TEMPLATES AND WIZARDS
AND STARTING FROM SCRATCH

CH3> ASSET-CREATION PACKAGES

Putting together your first website can be a daunting process, so to help you get started, this chapter will take you step by step through the production of a simple folio site. In doing so, I will use a variety of software tools and introduce a range of Internet terms and ideas. Even if your Web plans are more substantial and sophisticated than what I am starting with here, it is a worthwhile activity to produce a simple test site and learn the basics before implementing your fuller Internet dreams.

As we have already seen, modern Web software has demystified a lot of the site-production process and, for the most part, removed the need to hand code your pages in HTML. In addition, most current image-editing packages contain easy-to-use asset-creation features that enable the user to easily produce Web-ready graphics, buttons and headings.

Adobe Photoshop and ImageReady

Easily the industry leader, Photoshop (below) contains a huge set of image-editing and enhancement tools. More and more Web-specific features have been added in recent versions of the package eventually spawning the companion program, ImageReady. Designed specifically for creating and optimizing Web graphics, ImageReady (right), contains tools for creating rollovers, image maps, image slicing, animation, tiled backgrounds and compressed Web pictures.

Jasc Paint Shop Pro and Animation Shop

With a reported 20 million users worldwide, Paint Shop Pro (below) is an image-editing software success story. Jasc has provided a viable, affordable alternative to a lot of the more expensive packages. Paint Shop Pro and its companion product, Animation Shop (right), contain all the essential features you can use to help you create image slices and maps, as well as tools for picture optimization and the ability to create rollovers and animations.

Adobe Photoshop Elements

Elements (left and below) is the entry-level version of Photoshop. Designed to include the most frequently requested tools used by digital camera owners and basic image makers, this program offers a more affordable editing option than it's feature-packed big brother. It contains the same image optimization and Web photo gallery features as Photoshop, as well as the ability to make simple GIF animations from a layered PSD file.

Ulead PhotoImpact and GIF Animator

PhotoImpact from Ulead (below) is another entry-level image-editing package that offers a range of Web asset-creation tools. The program contains the standard image mapping, slicing and optimization features along with tools for creating pop-up menus, rollovers, mouse-over effects and scrolling text. In addition, PhotoImpact allows the user to create complete Web pages right from the image-editing workspace.

Macromedia Fireworks

Designed as the graphics component of the Macromedia spread of Web products, Fireworks provides high-level bitmap editing coupled with a host of specific Internet asset creation tools. The latest version of the software contains a step-by-step button maker, pop-up menu creator, selective JPEG compression and 'drag-and-drop' rollovers.

Software for assets other than pictures

Though most photographers will place a lot of attention on the production of optimized pictures for their sites, some may also want to include QuickTime virtual reality panoramas, sound, video and/or Flash animation as well. For this, take a look at the following programs as a starting point for each component type: Flash animation – Macromedia Flash, Adobe LiveMotion; Web video – Adobe Premiere, Ulead VideoStudio; QuickTime – Apple QuickTime Authoring Studio, PanaVue Image Assembler (below), MGI PhotoVista; Web sound – Syntrillium Cool Edit, Sonic Foundry Sound Forge, Gold Wave Digital Audio Editor.

PAGE-LAYOUT PACKAGES

Macromedia Dreamweaver

Dreamweaver is a popular choice for design-based site development. Built around a visual layout system, Macromedia prides itself in providing an interface and a way of working that is very intuitive. The software tightly integrates with sister products like Flash and Fireworks to provide a complete development suite.

Adobe GoLive

Adobe GoLive was developed to provide Web production features for dedicated Adobe users. This robust package ties in closely with Photoshop, ImageReady, LiveMotion, Premiere and InDesign. GoLive combines a visual layout approach with more sophisticated features like the type of database support used to create large and complex information-based sites.

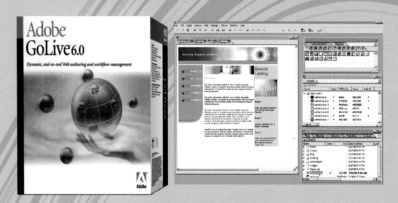

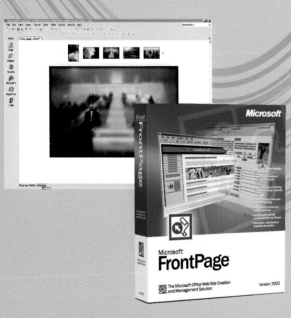

Microsoft FrontPage

Microsoft's foray into Web-design and -production packages has carefully evolved over the last few versions of FrontPage and is now a full production package capable of creating sophisticated websites. FrontPage not only provides a set of features and options that gives users the tools needed to make and publish their own pages from scratch, but the package also contains plenty of helpful wizards and templates providing a more automated approach to production.

Page layout using image editors

Though not specifically designed as Web-layout or -publishing packages, many of the current image editors contain all the tools needed to create simple websites. The software includos the expected image-optimization features that prepare and compress pictures ready for Web publishing, as well as Web-page production features that can be used to design and produce both Web pages and the most common page elements such as banners, button bars, rollovers, text and images. Of the current crop of programs, Photoshop (right) and PhotoImpact (below) are good examples of image editors that provide Web-production features.

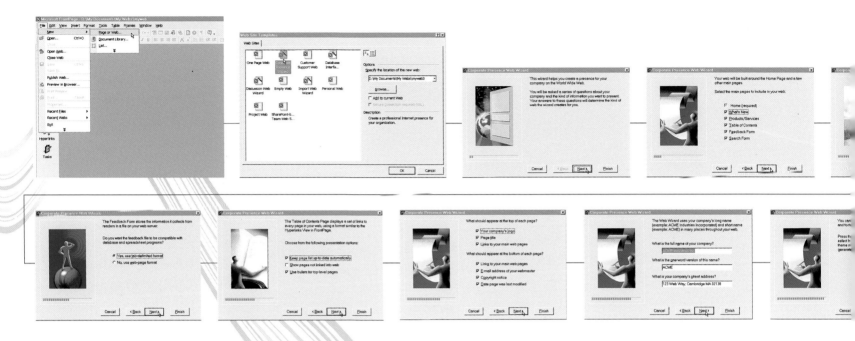

01 > Automated production features, sometimes called wizards, can make the completion of complex tasks easier than tackling them manually.

TEMPLATES, WIZARDS AND STARTING FROM SCRATCH

Unless you are a full-time Web designer, the prospect of having to master a website-production package, as well as the software that you use daily with your images, can seem very daunting. For this reason, several of the software manufacturers provide wizards or simple step-by-step guides to making basic Web pages and sites. Although it might first be a concern that by using one of these wizards, your sites will appear very similar to other sites created with the same package, there are usually enough variables in the process to help ensure visually different results.

The advantage of working in this way is that some of the learning curve associated with putting together functional and practical websites is alleviated. The program takes care of the underlying complexities of things like writing the code for rollover buttons, or embedding a third party plug-in that will display a movie file. Using these guides, the designer can concentrate on the visual layout of page elements rather than things like the correct syntax of HTML code.

Starting your design with a template can also speed up the production process used for creating websites. Often, the templates for Web design do not determine the look of the pages, but rather, determine how those pages function. For instance, the capturing of data from a Web form can be a complex matter. A 'form' template can contain the background code used to capture, sort and present the information input by a user. The designer maintains control over the look of the form, but the template provides the complex coding that is needed for the form to function. Used in this way templates can free the designer from having to learn a host of skills and techniques that often take them away from the pure function of getting your site on the Net.

If you want to maintain complete control over the whole of your site's design and production process, then it might still be a good idea to start your Net project with a wizard or template. This way you will learn the ropes from a designer (the wizard's author) who has been there before.

02 > Employing templates, if used carefully, can be a quick and efficient way to add functionality to your site.

CH4 > CREATING YOUR FIRST WEBSITE

CH4 > INITIAL DESIGNS

With your site's 'audience' and 'purpose' firmly in mind, it is now time to start the design process. You are probably already aware of the type of content that you wish to include – portfolio images, contact and biographical details, products and services – that you can offer customers. These items usually constitute the main components of a photographer's site. How you organize this information determines how entertaining, attractive and easy to navigate your site will be.

Drafting your design

Because most websites are a compilation of a series of screens linked with a navigation scheme, many designers sketch their initial ideas in the form of a flow chart. Essentially, this is a series of linked boxes. Each box represents a screen and its contents. The links between boxes show how the user can navigate between parts of a site.

The diagrams can be produced with pen and paper or by using a computer utility program. In fact, some of the more sophisticated Web design tools contain built-in flow chart design features. Adobe's GoLive contains an option that allows the user to visually sketch the pages and links of a new site and then, when the user is happy with the design, transport this rough plan to the full production part of the program.

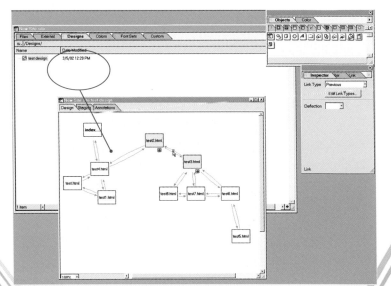

01 > Web layout programs with built-in design features enable Web workers to produce a general overview of their sites without having to build specific pages and links.

02 > Products like Adobe's GoLive take the design functionality further by enabling users to port their designs to the production area of the program.

Creating an assets list

During this drafting process, you should also start to consider the type of assets you will need to create to make your design real. You should list all the components that you wish to include on the site's pages and then break them into their information types. Headings, menus, images, buttons, text and links should all be detailed in your asset list.

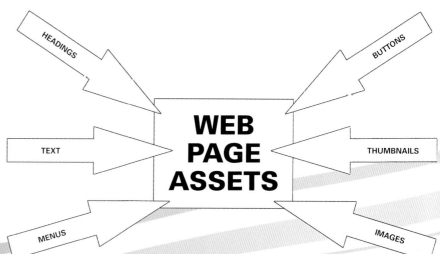

03 > The various visual and text components that go together to make up a Web page are called 'assets'.

04 > Images can be displayed on Web pages if they are compressed so that their file sizes are small enough to be downloaded quickly.

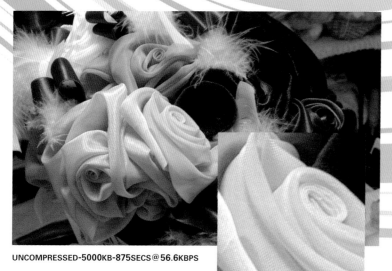

UNCOMPRESSED-5000KB-875SECS@56.6KBPS

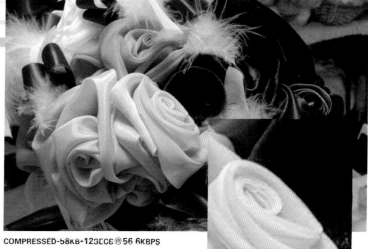

COMPRESSED-58KB-123SECS@56.6KBPS

Specifications and performance indicators

One area consistently overlooked by the new Web designer is the performance of the website. In this regard, speed is everything. There have been plenty of well-designed and visually splendid sites that never reach their full potential because of poor performance. The bigger the size of the files that make up your page, the slower it will download and the unfortunate truth is that pages that contain good-quality pictures can take ages to display. This poses quite a challenge for the photographer for whom images are usually the pivot point of their place on the Net.

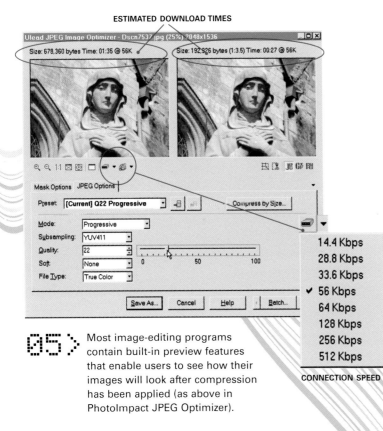

ESTIMATED DOWNLOAD TIMES

CONNECTION SPEED

05 > Most image-editing programs contain built-in preview features that enable users to see how their images will look after compression has been applied (as above in PhotoImpact JPEG Optimizer).

Quality versus download time

For the photographer, the entire production process is a balancing act between image quality and file size. Packages like Photoshop, Fireworks and PhotoImpact all contain special features designed to help squeeze good-quality pictures into tiny file sizes. In addition, they also provide indicators that estimate the download time of images at various connection speeds.

The following table provides estimated download times (seconds) using varying connection speeds for files of different sizes. Use this as a guide when you are designing the content of your pages and keep in mind that most Web gurus maintain that if a viewer has to wait more than 10-15 seconds to see a page, they will choose to go elsewhere.

Connection Speed (kbps)							
		9.6k	14.4	28.8	56.6	128	256
File	1.0	2	2	1	>1	>1	>1
Size	5.0	7	5	3	2	1	>1
(Kb)	10	11	8	4	3	2	1
	20	22	15	8	5	2	2
	30	33	22	12	6	3	2
	50	54	36	19	10	5	3
	100	106	71	36	19	9	5
	150	133	89	45	23	11	6
	200	213	143	72	37	17	9
	500	503	335	168	86	39	20
	1000	1006	670	330	175	80	40

Example site

To help guide you through the practical application of the ideas that I will be discussing in each section of this book, I will construct a series of example sites and pages, step by step, using a variety of the mainstream packages. Though not every stage will be shown for each program, all stages of the process will be detailed.

I also hope that you will be able to get an insight into the strengths of each of the particular software programs. Choosing which package you should use for the creation of your own site is a decision that should be based on:

> Your way of working.
> The software you already own.
> The size and complexity of your proposed site and, of course, your budget.

But before you reach for your wallet, check to see if a demonstration version of the software of your choice is available for evaluation. Most manufacturers will allow designers to download and use a time-limited trial version from their websites. This gives you the chance to ensure that the program suites your requirements.

> Initial designs (Adobe GoLive)

In this chapter, we will put together as an example a basic site for a children's portrait photographer.

1. A couple of the design considerations have already been decided: The purpose – to act as an on-line portfolio and contact point for potential customers. The audience – prospective customers who are looking for a children's portrait photographer.

2. The next step is to generate a few ideas about how the site will look and work. For this, I initially sketched out a few designs including a couple of sample flow charts showing pages and links. I have decided on a simple heading containing a graphic at the top of the page. Just beneath is a small button bar containing the four choices that lead to other pages.

3. With some basic ideas now 'on paper', I transferred these plans to the design feature in GoLive. I created a new site called 'Children's Portrait Photographer' (File>New>Blank). I then selected the Designs tab and switched views to Navigation view. The program automatically creates a page called 'index.html'. This is a specific name used by Web servers and shouldn't be renamed. Most people refer to this page as the site's 'home' page.

4. Using the icons in the menu bar, I added the four main pages under the first page (index.html). Notice how each page is linked independently back to this page. Under the folio page, I added three image pages that will contain example shots taken by the photographer. This design can be used as the basis for the full site later in the production stage.

5. Finally, now that I know the basic content and design of the site, I need to decide on some specification parameters. I believe that most of the audience will connect to the Net with a 56.6kbps modem or faster. I also want the pages to view in ten seconds or less for all but the folio pages that I am prepared to aim for 15 seconds. Knowing the slowest connection speed and maximum display times means that I can determine the biggest total file size of my page's combined assets: standard page = 50kb (max); folio page = 75kb (max).

06 > A few simple steps, and the information is transferred from paper to the site. The page automatically created by the programme is called 'index.html', otherwise known as the 'home' page.

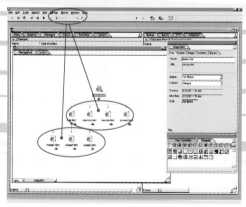

ADDING PAGES IN THE DESIGN STAGE

ORIGINAL FILE SIZE:
4300KB
COLOURS: 16.7MILLION

ORIGINAL FILE SIZE:
40KB
COLOURS: 16.7MILLION

ORIGINAL FILE SIZE:
475KB
COLOURS: 32

CREATING THE ASSETS

With the assets list in hand, file specifications sorted and a design drafted, it is now time to commence constructing the various components for the website. Let's start with the photographic images, as ensuring that these pictures display well is often a major concern for photographers designing their first pages.

Web-ready images and thumbnails

There are three important considerations when you are preparing your pictures for viewing on the Net.

1. Only certain types of image file formats can be viewed as a part of a Web page. The most popular of these are JPEG (Joint Photographic Experts Group) and GIF (Graphics Interchange Format). JPEG is mainly used for photographic imagery whereas GIF is often restricted to graphics and animated banners. I will discuss these and other Web file formats in more detail in the next chapter, Optimizing Your Pictures for the Web (see page 73).

2. In order to ensure fast download times the image files should be compressed. Both JPEG and GIF have methods for shrinking your picture files. Small image files make for fast sites. The more compression you use, the smaller your files will be, but this is at the cost of image quality. The compression factors for each file format can be set easily in your image-manipulation software. Most packages provide a preview of the compressed file so that you can gauge the degradation of the image before you save the file. Getting the right balance between image quality and file size is a critical task for the Web designer.

COMPRESSION AND FILE FORMAT SETTINGS

PREVIEWS WITH COMPRESSION

FILE SIZES AND DOWNLOAD TIMES

07 > GIF and JPEG are the most popular graphics formats used on the Net.

08 > For the best compromise between quality and download speed, preview screens as above prove invaluable.

1360 PIXELS

2050 PIXELS

800 PIXELS

1200 PIXELS

09 > The pixel dimensions of your image determines its size on screen.

530 PIXELS

800 PIXELS

3. The third factor to consider when preparing your images for the Net is the dimensions, or size, of your picture. Despite what you might initially think, the physical dimensions of your images are not expressed in centimeters or inches, but are measured in pixels. These dimensions will determine how big your picture will be on screen and its final file size. To determine the pixel dimensions that your images need to be, you need to decide what size you want them to appear on screen.

Computer screens can display images at a variety of resolutions measured by their pixel dimensions. You can change the resolution of your screen by altering the video settings in your operating system. If you think of your screen as a grid based on these dimensions, then the size of your digital picture can be plotted on the grid.

49

If the screen is 800 x 600 pixels and your picture is 800 x 600 pixels, then the image will fill the screen. If the picture is only 400 x 300 pixels, then it will be roughly one quarter of the screen. If the picture is 1200 x 800 pixels, then it will be bigger than the screen, and viewers will need to use the scroll bars to see the whole image.

As part of the website-design process, you need to determine what size you want your images to appear on screen. With these dimensions in mind, you will then be able to resize your pictures to suit.

A lot of photographic sites use a thumbnail/gallery picture approach to presenting images. Small index versions of your pictures with tiny file sizes are compiled on a single page to act as a quick loading guide to the folio. From here the user selects and clicks the picture they are interested in, and this transports them to a single page containing a larger, better-quality gallery version of the thumbnail.

Image-editing programs like Photoshop, Fireworks, Paint Shop Pro and PhotoImpact all contain special features designed to convert your masterpieces into Web-ready pictures. Most use a 'Save for Web' or 'Optimize for Web' function, complete with a built-in preview feature that allows the user to control the file format, compression and dimensions of the image.

THUMBNAIL IMAGE (100 x 60 PIXELS)

GALLERY IMAGE (1000 x 600 PIXELS)

11> Most gallery sites contain two versions of the one picture – a small version that is used as a thumbnail and a larger which is used in the final gallery view.

10> The pixel dimensions of the pictures you place on your Web page will determine how big they appear in a viewer's browser.

PICTURE - 800 x 600 PIXELS

PICTURE - 400 x 300 PIXELS

PICTURE - 1200 x 800 PIXELS

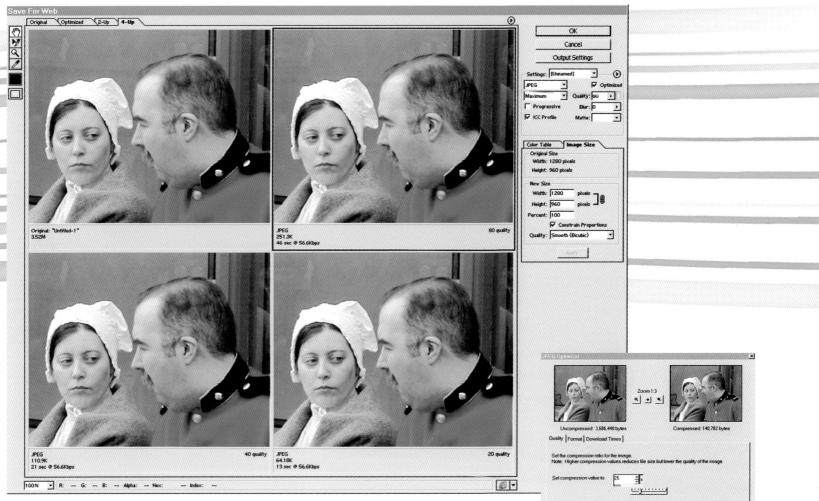

PHOTOSHOPS' SAVE FOR WEB FEATURE

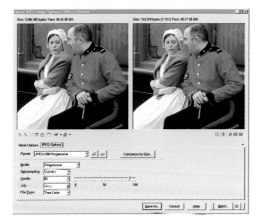

PHOTOIMPACTS IMAGE OPTIMIZER FEATURE

12> When preparing images for use in Web pages, the 'Save for Web' features contained in the major image-editing packages are critical for ensuring a good balance of image quality and file size.

PAINT SHOP PRO'S JPEG OPTIMIZER FEATURE

51

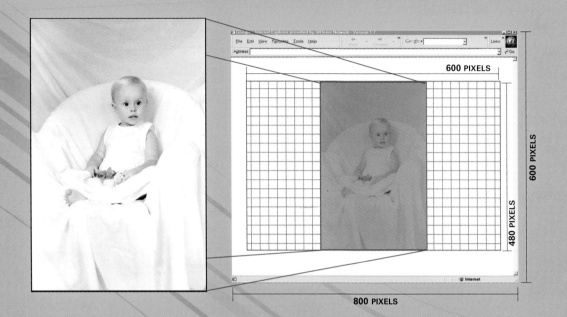

600 PIXELS

600 PIXELS

480 PIXELS

800 PIXELS

13> The picture is re-sized to suit the screen page.

Example site
> **Producing Web-ready images and thumbnails** (Adobe Photoshop)
As the example site contains a folio page and three image pages, I need to prepare both gallery and thumbnail images.

1. I have decided that I would prefer the gallery pictures to be seen in full when the computer monitor is on a modest resolution setting such as 800 x 600 pixels. Allowing for browser menus, website headings and scroll bars, I decide that the gallery images should fit within a portion of the screen measuring 680 x 480 pixels.

2. With Adobe Photoshop open, I then select one of the images that will be used for the folio and image pages.

3. I select the 'Save for Web' option from the File menu (File>Save for Web). In the new dialogue, it is possible to display the original image along with either one or three different versions of the optimized file.

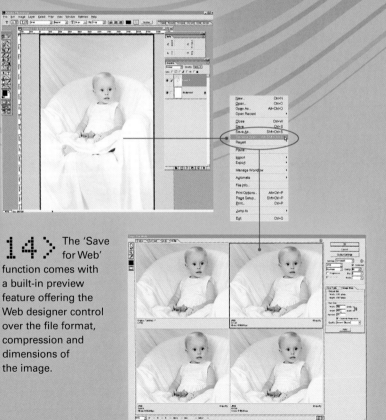

14> The 'Save for Web' function comes with a built-in preview feature offering the Web designer control over the file format, compression and dimensions of the image.

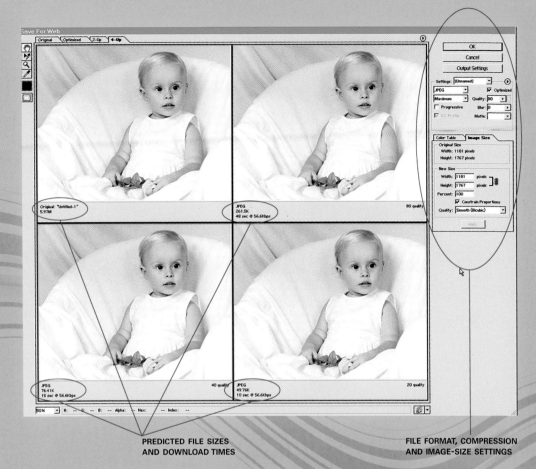

4. The settings for file format, compression and image size are changed using the controls in the top left of the dialogue. The predicted size and download time of the optimized file is displayed beneath the preview images, as demonstrated left.

5. With the image size adjusted so that it fits within the screen space (680 x 480 pixels), I altered the settings to provide me with the suitable file size and image quality; the optimized image is saved.

6. To make the thumbnails, I repeat the process using the 'Save for Web' dialogue to also reduce the image size as well.

 Many photographers display their work in both gallery and thumbnail format. The thumbnail format offers the viewer a quick way to see the photographer's work with all the images saved on one page in a small format. The larger format displays a better-quality version of the selected image.

PREDICTED FILE SIZES
AND DOWNLOAD TIMES

FILE FORMAT, COMPRESSION
AND IMAGE-SIZE SETTINGS

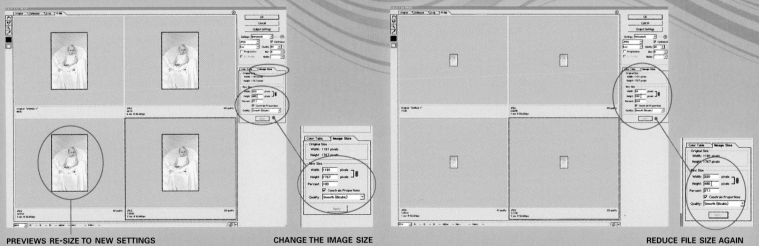

PREVIEWS RE-SIZE TO NEW SETTINGS

CHANGE THE IMAGE SIZE
TO FIT 680 x 480 PIXELS

REDUCE FILE SIZE AGAIN
AND SAVE AS THUMBNAILS

Buttons

Buttons are used extensively throughout websites to direct users from one page to another. Apart from straight hypertext links that make use of highlighted text to transport the viewer, most buttons are based on small image files. Though physically no different from the optimized pictures that we encountered in the previous section, button images have the added ability of being able to perform specific actions based on mouse position and button clicks. This function makes use of an extra piece of code attached to the picture in the layout phase of the Web-design process. So when producing button assets you should concentrate on creating the image-based button face.

More complex button designs, often called rollovers, change in appearance as the mouse cursor moves over them. The making of these types of buttons is discussed in detail in the Advanced Techniques chapter (see page 94).

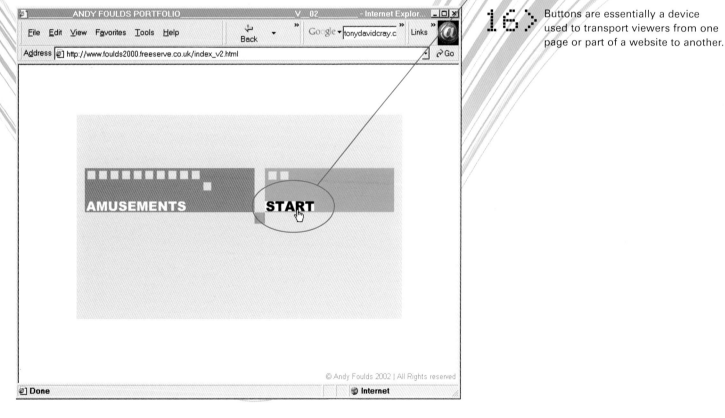

16> Buttons are essentially a device used to transport viewers from one page or part of a website to another.

Example site

⟩ Producing simple buttons (Ulead PhotoImpact)

Even the most modest image-editing programs are capable of producing a range of small images or icons that can be saved and used as buttons, but a few include wizards or features used specifically for this purpose. To produce some of the buttons for our example site, I will use PhotoImpact's Component Designer. It has a range of pre-designed buttons and button bars that can be customized to suit.

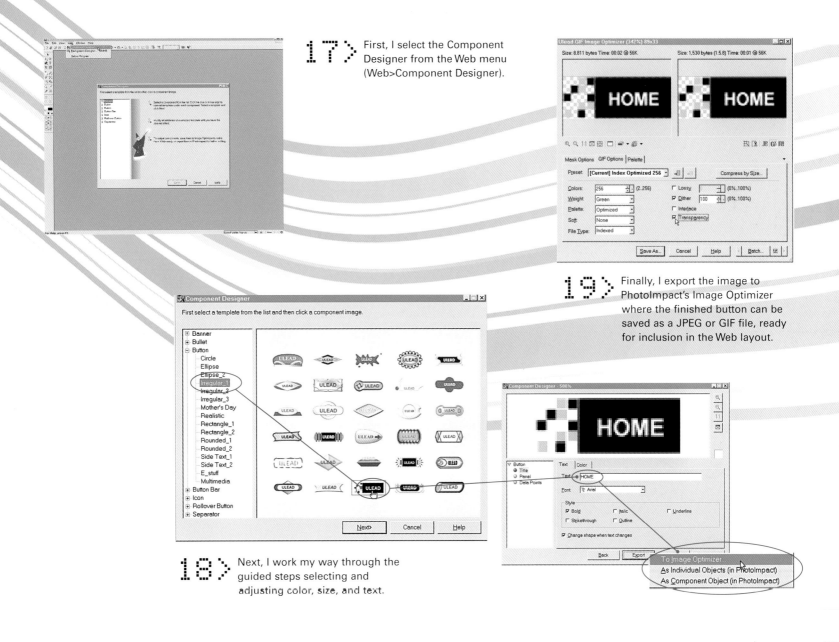

17⟩ First, I select the Component Designer from the Web menu (Web>Component Designer).

19⟩ Finally, I export the image to PhotoImpact's Image Optimizer where the finished button can be saved as a JPEG or GIF file, ready for inclusion in the Web layout.

18⟩ Next, I work my way through the guided steps selecting and adjusting color, size, and text.

Headings and banners

Headings, which are usually placed at the very top of the screen, provide a title for the page or site, and sometimes include a series of buttons called a menu or button bar. Again, this Web asset is usually created as a graphic and then placed on the page using a layout program. Keep in mind that just as much care needs to be taken when making and optimizing headings as any other graphics, as the speed that your page displays will be based on the combined file size of all the page's assets.

Banners are a favorite with many Web designers. They are essentially animated headings. Used often on commercial sites for advertisements, you will need to be careful with these devices as overuse can become annoying and a reason for not visiting your site.

PAGE HEADINGS

20> Most Web page headings are based on a single graphic that contains a combination of text and images.

Example site

> Producing Headings and Banners (Jasc Animation Shop and Photoshop)

For this example site, I will create a standard heading that will be used on all pages in the site, and a small simple banner for the home page that will announce special offers or site updates.

The heading needs to remind viewers that the site is representing a children's portrait photographer and also needs to link in with the buttons that were made in the previous section. For this reason the name of the photographer and a small sample picture will form the basis of the design.

21 To start a new document, the size of the heading (680 x 80 pixels) is created in Photoshop.

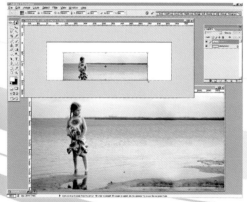

22 Next, the background was filled with a suitable color and an example portrait image was opened. The picture was re-sized, copied, pasted and then moved into place. Finally, a white frame and a drop shadow were added to the picture.

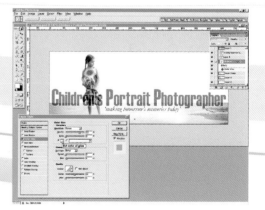

23 The photographer's name and slogan were added to the heading and a text style applied to the entirety. The 'Save for Web' option was used to optimize and save the picture in JPEG format.

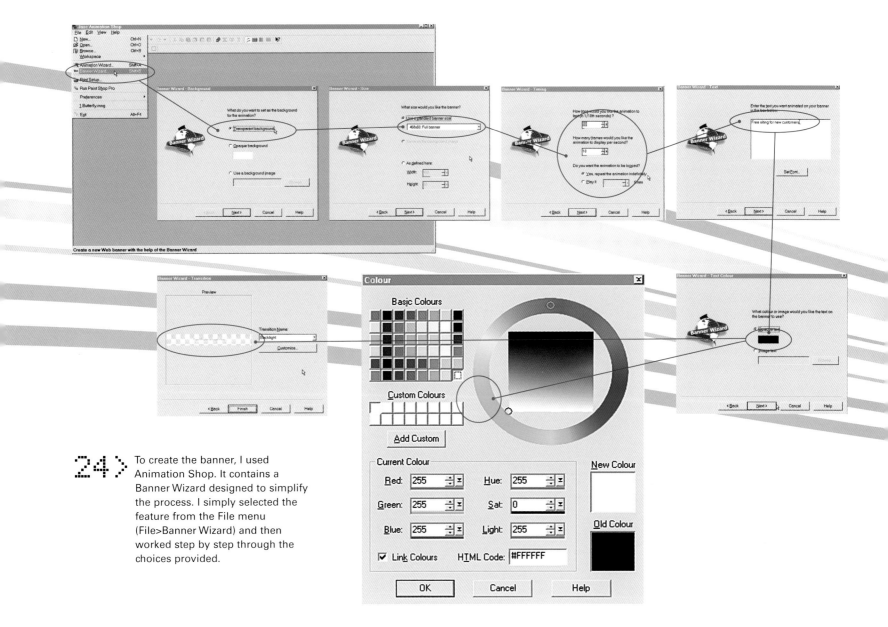

24> To create the banner, I used Animation Shop. It contains a Banner Wizard designed to simplify the process. I simply selected the feature from the File menu (File>Banner Wizard) and then worked step by step through the choices provided.

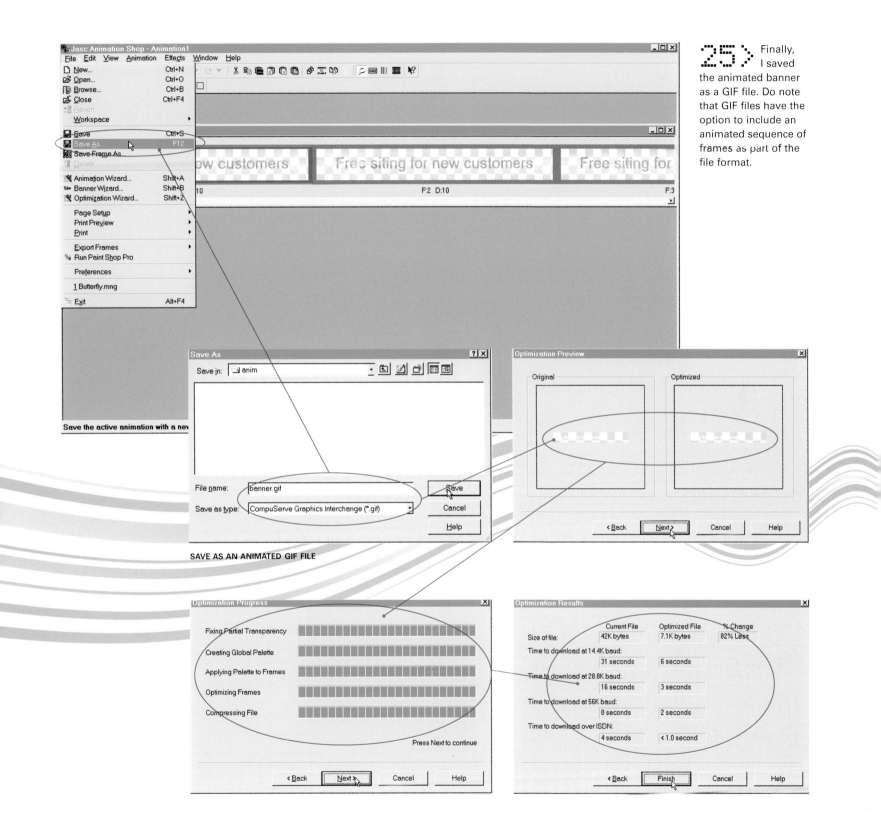

25> Finally, I saved the animated banner as a GIF file. Do note that GIF files have the option to include an animated sequence of frames as part of the file format.

SAVE AS AN ANIMATED GIF FILE

Body text

The text that you choose to include in your site can be typed directly in the Web-layout program. Alternatively, if you have the information stored in another form, it is often possible to copy and paste the text straight in. If you are producing an information-based site and have large amounts of data to Web-publish, some packages also allow you to link sections of your pages back to the source of the data. Programs like GoLive and Dreamweaver contain special features for linking directly to existing databases.

Example site

> **Producing body text** (Microsoft Word)

The photographer's résumé constitutes the main body text to be included in the sample site. This information is already stored in a Microsoft Word file and needs to be saved as 'text only' so that it can be copied straight into the layout program without any problems occurring because of hidden word-processing commands.

26> With the file open in Word, the Save As option was selected from the File menu (File>Save As). The document type was changed at the bottom of the dialogue to read 'text only' and the file saved.

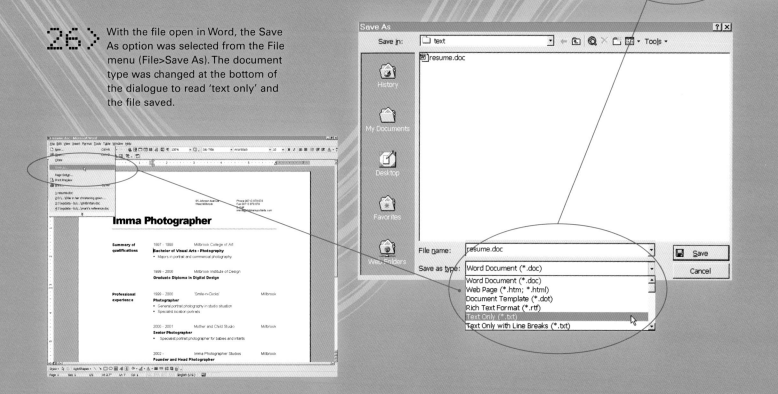

EXISTING RESUME IS SAVED AS A 'TEXT ONLY' DOCUMENT

Lines and rules (separators)

More popular a few years ago, rules, or thin graphic lines, are used to break up large areas of text or put some visual space between images. Most layout packages, as well as a few Web image-editing programs, are capable of producing these small, graphic assets.

Example site

⯈ Producing lines and rules (Microsoft FrontPage)

As part of the example site, I have placed a horizontal line, or separator, just above a small copyright statement at the bottom of the pages. Though inserting a line is a job carried out mainly by Web-production programs, and is not strictly an asset before the layout process starts, I have included it here, as it seems logical to do so.

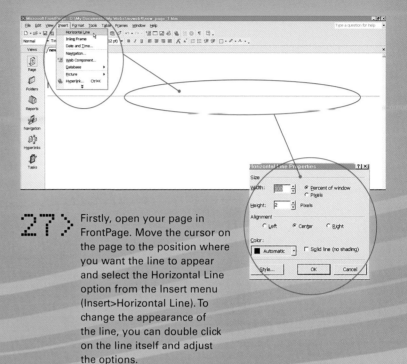

27 ⯈ Firstly, open your page in FrontPage. Move the cursor on the page to the position where you want the line to appear and select the Horizontal Line option from the Insert menu (Insert>Horizontal Line). To change the appearance of the line, you can double click on the line itself and adjust the options.

28 ⯈ FrontPage users designing pages around a pre-designed theme have more choice about the style of visual separator they can use.

Backgrounds

The HTML language has a specific feature designed for including backgrounds with your pages. As you can imagine, using a full-sized image for a background would greatly increase the file size and so the download time of your pages. In their wisdom, therefore, the early Web engineers included the ability to tile a small, graphic pattern over the whole of the background. In this way, a small,, highly optimized picture can be repeated in a grid over the expanse of the whole screen, giving the appearance of a seamless background with little download time cost.

Several of the imaging packages provide the tools needed to make a background tile. Some, like Adobe's ImageReady, include a tile-maker feature that automatically adjusts the edge of the graphic so that when it is repeated, the pattern is seamless.

Care needs to be taken when making backgrounds, as a tiled pattern that is too dynamic or colorful will not only detract from the text on the page, but could also make it more difficult to read. So, the rule of thumb is to use muted tones and soft patterns with few colors that are low in contrast.

Example site B
>Producing backgrounds (Adobe ImageReady)

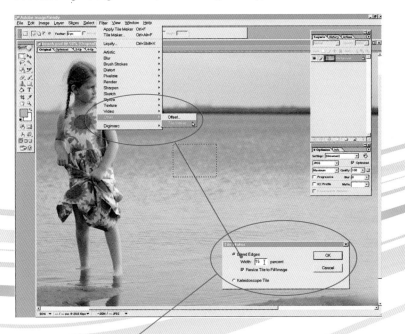

BAD BACKGROUND TILE

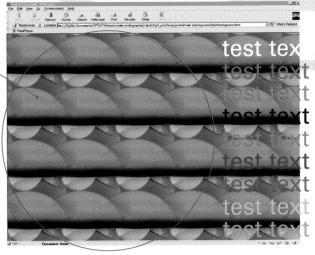

 29> Any images used in the background must be tested for legibility with a text overlay.

30> From the Filter menu, I chose Tile Maker (Filter>Other>Tile Maker), selected blend edge and clicked OK. With the tile area still selected, I cropped out (Image>Crop) the other parts of the image and saved the tile as an optimized JPEG file.

Organizing and naming the assets

The sheer number of files associated with any sizeable Web project makes tracking the different assets a difficult process. As part of the planning stage, it is important to establish a common approach to the storage of all of the project's components or assets. This means that a common naming standard needs to be set up and used across the whole of the project. As some Web storage servers are restricted to using an 'eight character - full stop - three character' naming system, this might be a good, base-level specification to use for naming all asset files.

Along with naming standards, it is also important to establish a hierarchy of folders or directories, to use to store assets, both when they are uploaded to the Web and when they are kept on your machine locally. Being clear about where specific files should be stored makes the production process quicker and any revision process performed on the site at a later date, more efficient.

The general rule of thumb used to divide and store the assets of a Web project is based on the types of files, or file formats, associated with each asset's contents. For instance, movie files, animation files, thumbnails and still images are usually separated into different folders or directories. These might be titled 'Movies', 'Anim', 'Thumbnails' and 'Images'.

SAVE TILE AS AN OPTIMIZED JPEG

PREVIEW NEW TILED BACKGROUND

31> To provide a subtle background, I made use of ImageReady's Tile Maker filter. I opened a picture and used the Rectangular Marquee tool to select an area of suitable tones.

filename.ext

EIGHT CHARACTER FILE NAME FILE EXTENSION

FULL STOP

32> Establishing, and sticking to, a naming convention will help prevent problems later when you are uploading your Web pages onto the Net.

SITE

IMAGES MOVIES PAGES

33> Storing your Web assets logically will help you keep track of your site's components.

LAYING OUT THE PAGES

Now that the major assets of the site have been created, the next step in the process is laying out the Web pages. Most Web layout programs provide a visual or WYSIWYG approach to this task.

First a new page is made. The size of the page is measured in pixels and should be based on the screen resolution already determined as the base size for your audience. From here on you can think of the page as a blank canvas upon which you will place, insert, draw or type your assets.

A new page needs to be created and saved for each of the sections of your design. To keep the design organized, it is helpful to make a new folder for each new page. In each folder or directory, you can store the page file (.html) and the assets needed for the page in their individual folders (images, anim, movies, etc.). If objects such as headings are repeated on several pages, then these don't need to be stored in each page directory. Instead, the asset can be saved in a 'common' directory. This way, each of the pages where it is used can point to this single asset. This saves Web server space and also means that if you want to change the asset, then you need only do it once.

Adding the assets

Layout programs take varying approaches to the adding of objects. The simplest, like Netscape's free Composer program, use a technique similar to word processors. Text is input directly onto the page, and images, headings and other assets are inserted into the text. Other programs, such as Adobe's GoLive, use a system similar to a desktop publishing program. Here, all the assets, including body text, are added to the page in layout boxes that can be arranged using a simple 'drag-and-drop' process.

There is also a group of image-editing programs that uses a picture-based approach to the whole process. Ulead's PhotoImpact is one such program. The Web page is constructed by placing assets on many different layers as if it were a standard image. Because of the layer approach, all the different components can be easily moved about and positioned. The final step is to export the picture as a Web page rather than an image file.

CHILDREN'S PORTRAIT PHOTOGRAPHER

COMMON — CONTACT — FOLIO — RESUME — SERVICES

ANIMS — BUTTONS — HEADING — IMAGES — SEPARATORS — THUMBNAILS

35 > The layout process involves bringing together the various assets needed to create the site. Each asset is stored on a separate layer.

34 > Store assets that are used more than once on your site in a common directory.

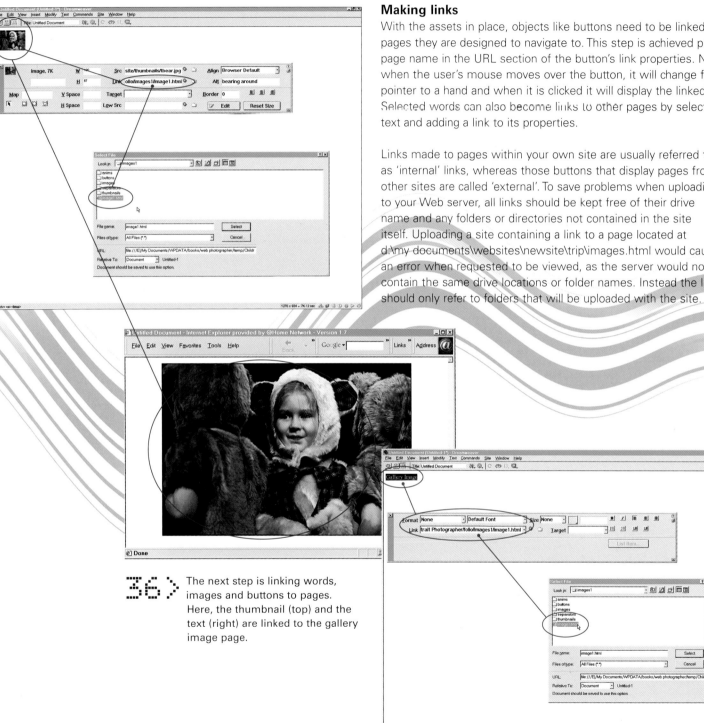

Making links

With the assets in place, objects like buttons need to be linked to the pages they are designed to navigate to. This step is achieved placing a page name in the URL section of the button's link properties. Now when the user's mouse moves over the button, it will change from a pointer to a hand and when it is clicked it will display the linked page. Selected words can also become links to other pages by selecting the text and adding a link to its properties.

Links made to pages within your own site are usually referred to as 'internal' links, whereas those buttons that display pages from other sites are called 'external'. To save problems when uploading to your Web server, all links should be kept free of their drive name and any folders or directories not contained in the site itself. Uploading a site containing a link to a page located at d:\my documents\websites\newsite\trip\images.html would cause an error when requested to be viewed, as the server would not contain the same drive locations or folder names. Instead the link should only refer to folders that will be uploaded with the site.

36 > The next step is linking words, images and buttons to pages. Here, the thumbnail (top) and the text (right) are linked to the gallery image page.

Example site

> Laying out the pages (Netscape Composer)

To start, I selected Blank Page (Blank for Mac OS) from the New option of the File menu (File>New>Blank Page). Choosing Image from the Insert menu (Insert>Image), I browsed and selected the background image that was created in the last section.

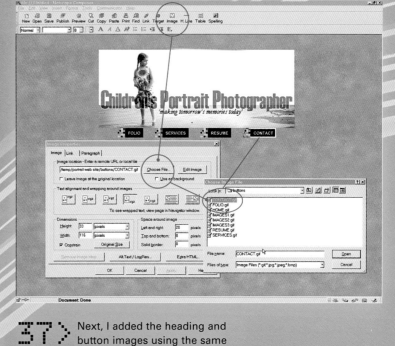

37 > Next, I added the heading and button images using the same menu selections. The pictures were positioned using the Alignment button and a few carriage returns.

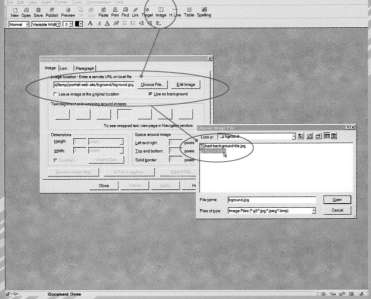

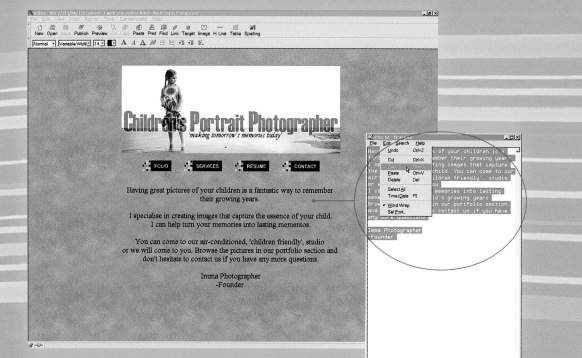

38> The body text was opened in a simple text editor and copied and pasted onto the page. Text sizing and styles can be adjusted using the options in the Format Menu. The rule or separator was added using the Horizontal Line button and was positioned just above a copyright statement.

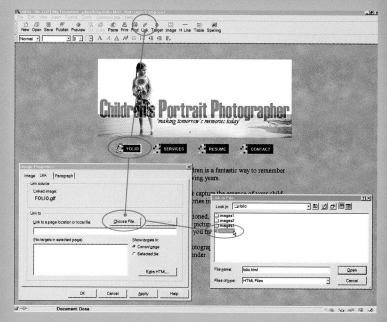

39> The other pages were made in a similar fashion and links were then made from the buttons to each page using the Link tab in the Image Properties dialogue.

67

TESTING THE SITE

Internal testing

A lot of testing occurs while you are constructing pages. A simple click of the preview button included in most layout packages provides immediate feedback on the success of your Web design decisions. It's a good idea to load several different browser packages onto your production machine so that you can test your site in more than one browser interface. Be careful not to take these live previews as a guarantee of trouble-free browser viewing though. To be sure that your site can be displayed without problem, you will need to undertake a series of separate and distinct tests.

When you have completed creating, laying out and linking pages, conduct your first 'run through' test by browsing your site outside of your Web production program. Check that all your assets display correctly and are in the right position. Next, ensure that all links are functioning and that all pages can be found when requested by a link. When you are satisfied that all is well, give the site to a couple of friends or associates, so that they can check it also. Try to find testers who have differing computer platforms, browser applications and browser versions.

After testing, there is always a list of repairs and changes that need to be made to correct or improve the site. These should be worked through methodically and a revised version of the site re-tested to ensure that these problems don't reoccur or new ones appear.

External testing

When you get to a position where all aspects of the site function correctly, the next stage of the process is to test your site on the Web. Some ISPs (Internet Service Provider) provide 'staging' servers where Web producers can upload and test their sites without actually publishing their sites to a public space. If you do not have this option, it is still important for you to upload your site to a Web server as testing your site on the Net is the only way that you are going to be able to gauge the download speeds of your pages and their images. Test display speeds by browsing the site using a variety of connection types – modom, cable, T1, etc. If you find that download speeds are unacceptable, then it may be necessary to change the acceptable files' size limit chosen early on in the design process. Such a change would require a re-optimization of graphic elements on larger pages, in order to meet the new, lower file size limits.

Finally, with the site still live on the staging server, re-check all links, assets and their positions to ensure that viewers will be treated to a trouble-free Web experience.

Use the following checklist as a guide for testing your site:

> All pages and assets have been included.
> All pages and assets display correctly and in position.
> All links work.
> Text is readable against background.
> All text is spelt correctly.
> Text displays in the correct position and wraps properly.
> Combined file sizes per page are acceptable.
> Download speed is acceptable.
> No changes in appearance of assets or layout because of browser, browser version or operating system differences.

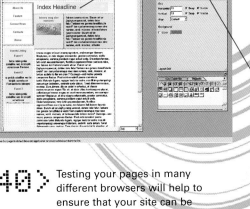

40 > Testing your pages in many different browsers will help to ensure that your site can be viewed by the majority of your Web audience.

Example site

> Testing assets, pages and the sites (Adobe Photoshop, Adobe GoLive, Microsoft Internet Explorer, Netscape Navigator, Opera)

Asset testing: During the asset production process, the various graphic components of the site were constantly tested by using the preview features in the production package. Particular attention was paid to ensuring that the images displayed well on both Macintosh and Windows platforms.

Internal site testing: Completed pages and the finished site itself were tested in a range of Web browsers, browser versions and the same browser run on a different operating system (Macintosh and Windows).

External site testing: Once any initial problems were corrected and the site ran trouble free in a range of environments, it was uploaded to a Web server and the pages were tested for download speed.

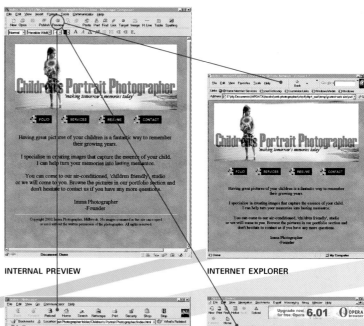

INTERNAL PREVIEW **INTERNET EXPLORER**

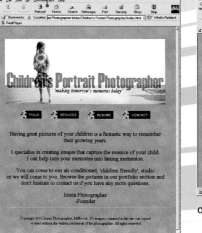

NETSCAPE **OPERA**

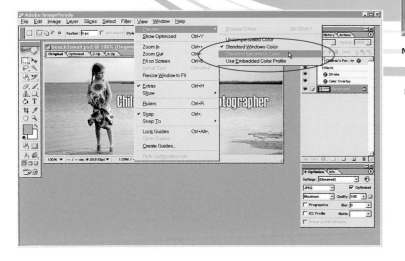

 To ensure that all aspects of the example site function correctly, a series of test stages were used.

PUBLISHING

Now that you have a well-designed, squeaky clean website that downloads quickly and contains no errors, you can publish your hard work to a public site and let the rest of the world view your masterpiece. To put your site online you will need to secure some Web space with an ISP, or Internet Service Provider. Chances are you are already using a provider to access the Net via your modem or cable connection. As part of this service most companies provide space for your own website.

Alternatively you can secure free web space through Web companies like www.50megs.com, who provide site space in return for placing banner ads at the top of your page. For a completely professional site that contains less restrictions and no advertisements you will have to pay hosting charges. These start at about USD$5.00 per month depending on traffic, maximum file sizes and total website size.

Domain names

When using space purchased from a Web hosting company or from your ISP, you will be allocated a Web address based on the provider's name. A typical address might be www.massiveISP.net/members/~myhomepage. This might not be a problem for a personal site, but most businesses prefer a dedicated name linked to their company's identity. To obtain a specific Web address you need to register a domain name. This can be achieved online using any one of dozens of domain registration services.

Names can be selected with a range of endings from the ubiquitous '.com' for company sites, to '.org' for organisations and '.net' for networks. You can also choose country-specific endings such as '.com.au' for a company in Australia, '.co.uk' for a United Kingdom based business and '.co.jp' for Japan. The name you select should be based on the type of business you have, the scope of its activities and domain names available. Once registered, you can get your ISP to host the name as well as your site.

Uploading your site

To upload your files you will need to contact your provider and obtain at least three pieces of information: the upload site address, your login name and your password. These details are used by your layout, or FTP (File Transfer Protocol) program, to connect your computer with the server. Using either a dedicated program like CuteFTP from GlobalSCAPE, or taking advantage of FTP or publishing options built into your layout package, connect to your Web server and upload your files by dragging them from your local drive to the drive space given to you by your provider. Once the file transfers are complete, browse your pages to check that your site is functioning correctly.

Example site

⟩ Publishing

For the purposes of this example, I registered the name
kidsportraits.50megs.com with 50megs.com. Although this is a free
Web hosting, 50megs provides its customers with a fee sub-domain
name as well as free space for your site files. The downside is that
every time someone views the example site, they will also see a
banner advertisement at the top of the page.

42 ⟩ During the registration process, the Web host company
provided me with a logon name and a password, as well as
instructions on how to upload my files to the file server.
Using an FTP program, I transferred the site's files to the
hosting computer. I was then able to browse the example site
like any other.

CH5> OPTIMIZING YOUR PICTURES FOR THE WEB

CH5> OPTIMIZING PICTURES

Photographers, by their very nature, value their pictures. They see the task of transferring their images to the Net as critical. They want the Web versions of their photographs to display all the skill and care taken in their production. This is natural. The problem is, as we have already seen, that high-quality digital pictures have large file sizes and take an age to download. And, as we know, slow displaying pages turn site visitors off.

The skill of making a highly visual site that downloads quickly is largely based on how well you optimize the picture elements contained in the pages of the site. For this reason, the following chapter concentrates on techniques and ideas that you can use to shrink the size of your picture files.

WEB GRAPHICS FORMATS

The way the Net works means that only certain file formats can be used to display pictures contained within Web pages. It used to be the case that JPEG and GIF formats were the only choices available to the Web photographer, but gradually other options have been appearing. As size is critical all of the formats contain a method of reducing or 'compressing' the image file into as few kilobytes as possible. So before we explore the different file options, let's start with a few ideas about compression.

ORIGINAL IMAGE

COMPRESSED FILE

DECOMPRESSED IMAGE

01> The image is stored in the compressed state and then decompressed when viewed with a browser.

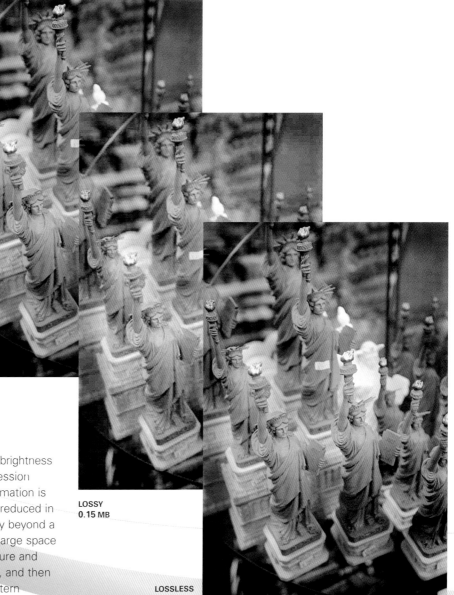

02 > Extremely small file sizes can be obtained using lossy compression where as only moderate compression is possible with lossless file formats.

ORIGINAL
3.0 MB

LOSSY
0.15 MB

LOSSLESS
2.0 MB

Image compression – lossy and lossless

Most digital picture files store information about the colour, brightness and position of the pixels that make up the image. Compression systems reorder and rationalize the way in which this information is stored. The result is a file that is optimized and, therefore, reduced in size. The mathematics involved in these operations are way beyond a simple image maker like myself. However, I do know that large space savings can be made by identifying patterns of colour, texture and brightness within images, and storing these patterns once, and then simply referencing them for the rest of the image. This pattern recognition and file optimization is known as compression.

Most compression and decompression processes, or CODECs, contain three stages:

1. The original image is compressed using an algorithm to optimize the file.

2. This version of the file becomes the one that is stored on your hard drive or website, and...

3. ...the compressed file is then decompressed by your browser, ready for viewing.

If the decompressed file is exactly the same as the original, then the process is called 'lossless'. If some image information is lost along the way, then it is said to be 'lossy'. Lossless systems typically can reduce files to about 60% of their original size, where as lossy compression can reduce images to less than 1%.

There is no doubt that if you want to save space and maintain the absolute quality of the image, then the only choice is the lossless system. A good example of this would be photographers or illustrators archiving original pictures. The integrity of the image in this circumstance is more important than the extra space it takes to store it. The TIFF (Tagged Image File Format) provides lossless compression and is widely used by the graphics and publishing industry for instances when space and transmission speed is not as critical as absolute quality.

On the other hand (no matter how much it goes against the grain), sometimes the circumstances dictate the need for smaller file sizes – even if some image quality is lost along the way. All of the images that you see on the Web are based on this premise. The time it takes for a Web picture to appear on screen is directly related to its file size. For this reason, image quality is willingly sacrificed for the sake of small file sizes and fast transmission. The JPEG (Joint Photographic Experts Group) format uses lossy compression to squeeze images down to incredibly small file sizes and is used for Web work, or press transmission.

How lossy is lossy?

The term lossy means that some of the image's quality is lost in the compression process. The amount and type of compression used determines the look of the end result. Standard JPEG and JPEG2000 display different types of 'artefacts', or areas where compression is apparent.

To help ensure that you have the best balance of file size and image quality, make sure that you use a program that contains a preview option and that you always examine the compressed image at a magnification of 100% or greater. This way, unacceptable artefacts will be obvious.

03> The more lossy the compression used on a picture, the more apparent the artefacts will be, or image errors that result from this process. It is the web designer's job to balance file size and image quality.

STD JPEG

HALO EFFECTS

BLOCKING

DETAIL LAW

JPEG 2000

GENERAL BLUR

SHARP/BLUR AREAS

DETAIL LOSS

GRAPHICS VERSUS PHOTOGRAPHY

The image file formats suitable for Web work can be broken into two groups:

Graphics

The first group is suitable for graphical images containing a limited number of flat colours. GIF and SVG are two formats used for this type of picture.

1. GIF, or the Graphics Interchange Format, is a comparatively old file format. It has the ability to compress images mainly by reducing the number of colors they contain. For this reason, it is great for headings, logos and any other artwork with limited colors and tonal graduation. It can also display pictures that contain areas of transparency and can be used for simple cell-based animation. The format cannot, however, display more than 256 colors and so shouldn't be used for photographic images unless they contain a very limited color set.

2. SVG, or Scalable Vector Graphics, is a new format designed specifically for Web use. The format creates smaller images than both GIF and JPEG. It is also capable of complex animations; parts of the image can be linked easily and any text contained in the picture can be searched in the browser. One of the best features of the format, though, is its ability to be scaled up and down without any loss in quality. The downside to the format is that most browsers do not automatically support it. A plug-in must be downloaded and installed to ensure that SVG pictures can be browsed. As the format's popularity grows, so too will its implementation into the mainstream browser programs.

3. SWF, more commonly know as the Flash file format was designed by Macromedia as a Web format that was capable of delivering graphics, animation and sound in a very small file. Like SVG it uses vector graphics and so is best used for flat areas of color with little gradation of tone. The majority of the fully audiovisual websites that you experience on the Net are delivered in the Flash format. SWF files can be displayed in browsers containing the Flash plug-in or viewer. The format is not generally used for photographic images, but it certainly is used by plenty of photographers to create a visually dynamic front end to their gallery sites.

Photography

The second group of formats is best used for pictures that contain a large range of colors and areas of gradated tone.

1. JPEG, JPG, or Joint Photographic Experts Group, is a file format specially developed for Web images. It uses a lossy compression technique to reduce files to as little as 5% of their original size. In the process, some of the detail from the original picture is lost and 'telltale' artefacts, or visual errors, are introduced into the picture. The degree of compression and the amount of artefacts can be varied so that a balance of file size and image quality can be achieved. JPEG images can contain millions of colors rather than the comparatively few available when using GIF. The format has massive support on the Net and constitutes the main way that photographers display their Web pictures.

2. JPEG2000, or JPG, is a revision of the format that uses wavelet technology to produce smaller and sharper files than traditional JPEG. The standard also includes options to use different compression settings and color depths on selections within images, as well as being able to save images in a lossless form. The downside to the new technology is that to make use of the files created in the JPEG2000 file format, you will need to install a plug-in into your Web viewer or image-editing program. Native browser support for the new standard will undoubtedly happen but until then we all will need to install support programs to get the JPEG2000 advantage.

3. PNG, or Portable Network Graphics, is a format that contains a lossless compression algorithm, the ability to save in 48-bit color mode (twice as much as JPEG) and a feature that allows variable transparency (as opposed to GIF's on-and-off transparency choice). File sizes are typically reduced by between 5 and 25% when saved in the PNG format. Though this is a great saving for files that retain the integrity of the original picture, for most Web work, JPEG is still best. The latest browsers support the PNG format natively so no extra viewer plug-in is necessary. A version of the format called MNG, or Multiple Network Graphics, contains the ability to animate multiple frames, but as yet, it hasn't been widely accepted, nor supported, by the major browsers.

The generic format

There is a small, but significant, third file format category that is dominated by the Adobe Acrobat format.

1. The PDF, or portable document format, is fast becoming a standard for describing the text, graphics, image and layout components of various documents. Originally used for creating self-contained electronic documents from page-layout programs, the latest version of the product is also suitable for saving images. When used in conjunction with Photoshop it is possible to save picture files with lossy JPEG or lossless ZIP compression. You can also secure the file so that it can only be opened with a supplied password. Though not natively supported by the major browsers, PDF files can be viewed on or offline using the free plug-in.

SIDE-BY-SIDE FORMAT COMPRESSION

To help you make sense of these options, I have created a standard image containing both flat poster-like graphics and gradated photographic tone. I then saved the picture in different file formats using a variety of settings. The resultant images, their file sizes and predicted download times, give you an indication of the capabilities of each of the formats.

PHOTOGRAPHIC TONE

FLAT COLOR

SHARP-EDGE GRAPHICS

04 > The example image contains both flat areas of color as well as subtle gradations of tone to help emphasize the capabilities and features of each format.

Formats summary – best uses								
	Image Type/Feature							
	Photograph	*Logo*	*Heading*	*Animation*	*Transparency*	*Security*	*Searchable*	*Example*
Format								
JPEG	✓							
JPEG 2000	✓							
PNG	✓	✓	✓		✓			
GIF		✓	✓	✓	✓			*Fig 05*
SVG		✓	✓		✓		✓	
SWF		✓	✓	✓	✓	✓		
PDF	✓	✓	✓			✓	✓	

GIF FILE FORMAT

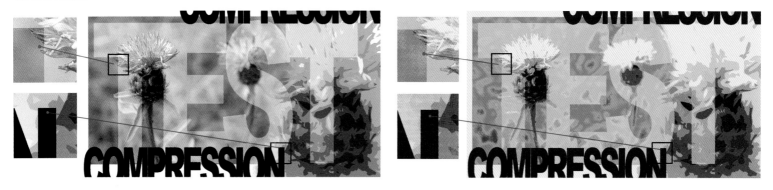

SETTINGS: 256 COLOURS FILE SIZE: 1.65MB
DOWNLOAD TIME: 308 SECS @ 56.6 KBPS

SETTINGS: 4 COLOURS FILE SIZE: 0.23MB
DOWNLOAD TIME: 43 SECS @ 56.6 KBPS

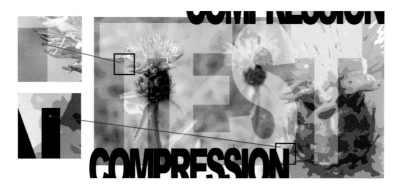

SETTINGS: 64 COLOURS FILE SIZE: 1.10MB
DOWNLOAD TIME: 203 SECS @ 56.6 KBPS

 GIF is still used extensively for simple animations and graphics with limited colors or transparent areas.

CHOOSING YOUR COMPRESSION SOFTWARE

Though most image-editing packages like Photoshop and Fireworks provide 'Save for Web' features complete with compressed image previews for the major formats (JPEG, GIF and PNG), there are several specialist products that can also be used. Some of these programs are stand-alone pieces of software, others are used as plug-ins for packages like Photoshop.

ProJPEG

Boxtop Software's ProJPEG plug-in for Photoshop, is a specialist compression dialogue that allows users to regularly produce smaller standard JPEG files than those output from Photoshop.

Power compressor

The Image Power stand-alone compressor is capable of outputting files using either standard or JPEG2000 compression. It offers flexibility for those users who need access to both systems. Image Power also provides an Internet Explorer or Netscape viewer that will allow others to view the really tiny JPEG2000 files that the program produces. If you have a small set of 'viewer-enabled' customers or partners in your workgroup, then this package could cut down your total transmission time considerably as well as still giving you the option to output to standard JPEG.

Lurawave

Algo Vision's programs use JPEG2000 compression technology to save lossless or lossy versions of your image files. As well as a stand-alone version, SmartCompress, plug-ins are available for Photoshop, Paintshop Pro and even desktop publishing software like Quark Xpress. All products allow compression to file size, quality setting or compression ratio. Using a free viewer add-on, the final LWF or JP2 file can be viewed online in either Internet Explorer or Netscape.

- ✓ LOSSY
- ✓ STD.JPEG
- ✓ PHOTOSHOP PLUG-IN
- ✓ WEB READY
- ✓ COMPRESS TO .006%
- ✓ EXT.JPG

- ✓ LOSSLESS/LOSSY
- ✓ JPEG 2000
- ✓ STAND ALONE
- ✓ WEB PLUG-IN
- ✓ COMPRESS TO .004%
- ✓ EXT.JPC

- ✓ LOSSLESS/LOSSY
- ✓ JPEG 2000
- ✓ PHOTOSHOP PLUG-IN
- ✓ WEB PLUG-IN
- ✓ COMPRESS TO .004%
- ✓ EXT.JPC

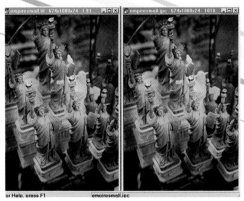

 Boxtop software's ProJPEG program for JPEG compression.

 Image Power's Power Compressor program generates JPEG and JPEG2000 files.

08> Algo Vision's Lurawave produces image files with JPEG2000 compression.

PhotoImpact

Ulead's PhotoImpact is the first of the major image-editing packages to include a JPEG2000 'save' option. Though not yet a feature that includes a preview of the compressed image, it is a sign that the new version of JPEG will gradually become more and more accepted.

- ✓ JPEG 2000
- ✓ PHOTOSHOP PLUG-IN
- ✓ WEB PLUG-IN
- ✓ COMPRESS TO .004%
- ✓ EXT.JP2

09 > Ulead's PhotoImpact software is an image editor with JPEG2000 output options.

Photoshop

The latest version of Photoshop expands its PDF output options to include Adobe's latest security features. Now it is possible to email or download high-quality photographs that can be viewed but not printed or opened without a password. When this is combined with the ability to save files with either lossy JPEG or lossless ZIP compression, PDF has to be considered for online delivery of quality images.

- ✓ PDF FORMAT
- ✓ NATIVE PHOTOSHOP
- ✓ WEB PLUG-IN
- ✓ COMPRESS TO 10%
- ✓ EXT.PDF

10 > Photoshop can output directly to PDF format making use of Adobe's advanced security features as well as in-built compression options.

BALANCING COMPRESSION AND IMAGE QUALITY

The Web designer is always caught between the two opposing forces of image quality and image file size. The manufacturers of the major image-editing packages are well aware of this difficulty and, to this end, have created sophisticated compression features that give the user a range of controls over the process. Use the following guide and tips to help make smaller files:

1. Load the image into the compression software. Unless you are working with a particular audience group, this will mean using a program that can output either GIF or JPEG files (or both). In this guide, we will use Photoshop and its 'Save for Web' feature.

Step Summary: Open Photoshop. Open original image (File>Open).

2. Re-size the original image to fit the pixel dimensions already determined in the designing stage.

Step Summary: Select Image>Image Size. With Resample and Constrain Proportions options selected, input the new pixel dimensions for the image.

3. Start the optimization by selecting the 'Save for Web' feature.

Step Summary: Select Save for Web (File>Save for Web).

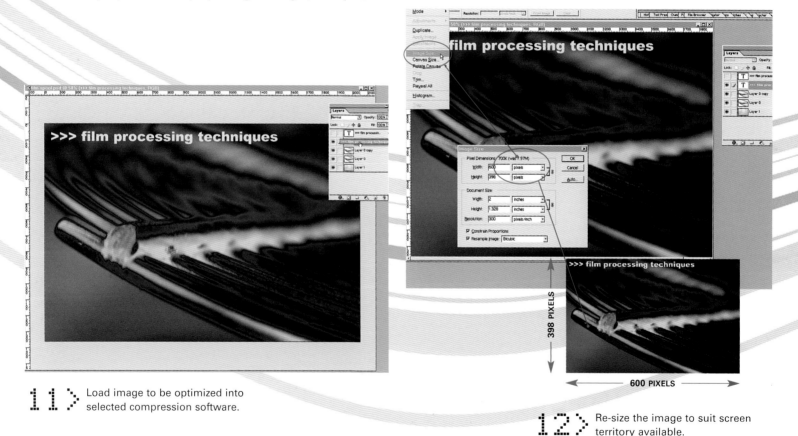

11> Load image to be optimized into selected compression software.

12> Re-size the image to suit screen territory available.

4. Using the previews at 100% as a visual guide, try a range of file formats, compression settings and number of colors to determine the best balance of file size and image quality.

Step Summary: Select the 4-Up tab at the top of the previews. Alter the format, compression and color values in the settings dialogue.

5. Check that the predicted download times are within the acceptable limits determined in the designing stage.

Step Summary: Check the predicted download times and file sizes beneath each of the preview windows. Change the transmission speed using the menu opened with the side arrow located at the top left of the preview area.

6. Alternatively you can skip steps 4 and 5 and use the Optimize to File Size feature that will automatically find the best settings to obtain a set file size.

Step Summary: Select the Optimize to File Size using the menu opened by the side arrow next to the settings part of the dialogue. Input the target file size into the pop-up window.

7. Save the optimized file.

ORIGINAL

13> Open the optimization feature.

FORMAT SETTINGS

OPTIMIZATION PREVIEWS

16> Use the Optimize to File Size feature for a more automated approach.

14> Change compression, format and color settings until a suitable compromise of image size and quality is found.

15> Check predicted download times are suitable for overall Web design.

17> Save or export the optimized image file.

TIPS FOR GOOD IMAGE COMPRESSION

1. Always use a compression tool that has a side-by-side preview of the original and compressed image.

2. For GIF images, try reducing the numbers of colors to gain extra compression.

3. Always view the compressed image at 100% or more so that you can see any artefacts.

4. For JPEG images, carefully adjust the quality slider downwards to reduce file size.

5. Take notice of the predicted file size values when compressing images. Relate this back to the maximum file sizes that you determined in the planning stages of the website design.

18> The color depth of an image determines the total number of colors possible for that image and is measured in 'bits'.

24 BIT (16.7 MILLION COLORS)

8 BIT (256 COLORS)

4 BIT (16 COLORS)

1 BIT (2 COLORS)

DEALING WITH ARTEFACTS

Converting images to either JPEG or GIF formats, means that some of the image quality of the original picture is discarded to reduce file size. The compression is necessary but if too much is applied, the degradation of the image becomes very noticeable.

With JPEG, these errors or artefacts take the form of halos around the image, blocking of the pixels, reduction in colors and a general fuzziness. For GIF images, the main type of artefact is posterization where the number of colors used isn't sufficient to represent gradated tone. The result is large areas of solid flat color where delicately changing hues should be. To reduce the artefacts in your image, try using less compression for JPEG images or more colors for GIF.

19> For ultimate consistency between viewing computers, you should select colors for your site from the Web-safe color palette, which can be displayed equally as well on both Windows and Macintosh platforms.

COLOR PALETTES

Current industry statistics show that over 90% of Web users access the Net with computers that are capable of displaying millions of colors or 24-bit color. This hasn't always been the case; only a few years ago, the majority of Net surfers owned machines that could only display 256 colors (8-bit color). This meant that all images used on a website had to be made up of this limited palette if they were going to display correctly on the Net.

To add to this restriction, the Macintosh and Windows platforms reserved some of the 256 colors for their own system colors. This meant that, in reality, there were only 216 colors with which you could describe your pictures and other graphical page elements. Good designers who restricted their masterpieces to these few colors would be able to guarantee that the pages would display properly on both computer platforms.

Now that most surfers have machinery capable of showing more colors, the need to optimize your images so that they fit within a Web-safe palette has largely been eliminated. Most new Web producers ignore the Web-safe palette, save exceptional cases where they are sure that their site visitors will be viewing pages with 8-bit or 256 color systems.

MAC OS SYSTEM PALETTE　　　　**WINDOWS OS SYSTEM PALETTE**　　　　**WEB-SAFE PALETTE**

WHAT IS THAT COLOR? THE DREADED HEX...

One of the hangovers from having to be very prescriptive about the exact type and number of colors used in a Web picture is the HEXADECIMAL system. Using this naming convention it is possible to describe a specific digital color precisely. It is very useful for ensuring that the specific colors you pick for your website remain consistent across all pages.

Image-editing packages with Web abilities usually provide the option to view and sample your image colors in a range of formats. The information displays can be altered to show the value of the color in HEXADECIMAL for Web, RGB (Red, Green, Blue) for pictures captured with a digital camera, and CMYK (Cyan, Magenta, Yellow and Black) for printing.

In Photoshop, you can alter the color swatches so that they only display the hues from the Web-safe color palette. You can also change the Show Info feature so that it shows the hex values of selected colors. With Fireworks, both the info and color swatches can be changed to show hex values and use Web-safe palettes.

Specifying a particular color is as simple as sampling the hue from an existing image or the swatch palette, noting its hex value and then using this value each time you want this exact color. The value can be used in the image-editing software at the time of asset creation, or in the production package during the page layout stage.

RGB - 255, 48, 22
HEX - FF3016

RGB - C, 249, 44
HEX - 00F92C

RGB - 255, 253, 51
HEX - FF033

RGB - 0, 39, 251
HEX - 0027FB

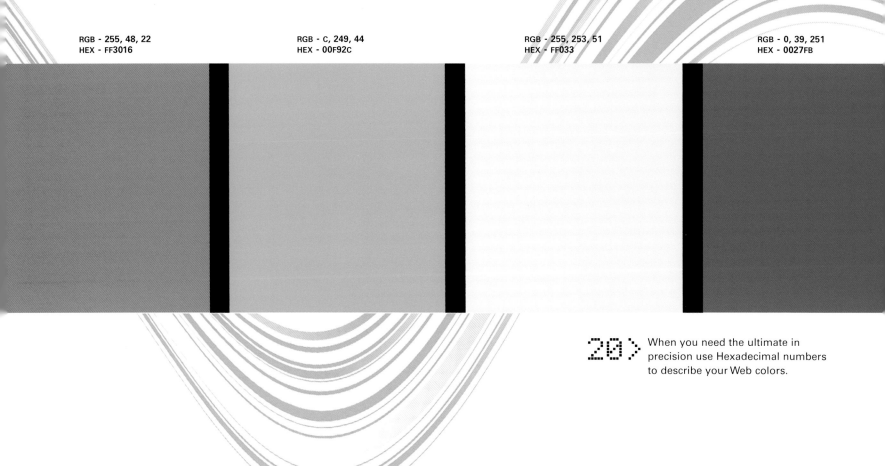

20 > When you need the ultimate in precision use Hexadecimal numbers to describe your Web colors.

REMAPPING COLORS TO TRANSPARENCY

Photoshop (and ImageReady) contain a Remap to Transparency option in their 'Save for Web' feature. From inside the dialogue, and with the GIF file format selected, the designer uses the eyedropper to select a specific color to map to transparent. This highlights the color in the image's color table. Now when the Transparent button at the bottom of the palette is clicked, all pixels with this color value in the image will be made transparent.

Other colors can be successively added to the transparent area in the same manner and all changes can be reversed by selecting the appropriate color in the CLUT (color look-up table) and then clicking the Transparent button. The preview is updated immediately and only the optimized file is altered.

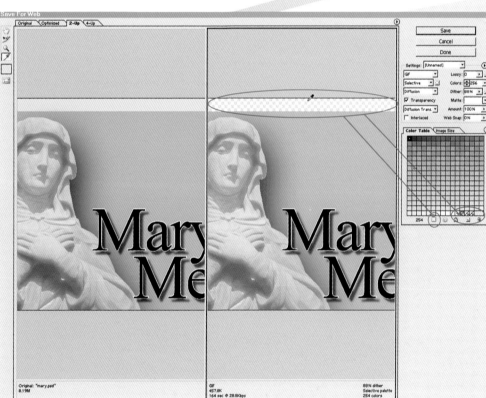

21> The major image-editing and Web-optimization packages such as Photoshop/ImageReady (top) and Fireworks (above), contain info palettes that enable you to determine the exact hex value for any Web-ready color.

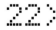 The ability to remap colors to transparency as part of the Web-optimization process enables the designer to quickly reuse existing graphics for Net uses.

DITHERED TRANSPARENCY EFFECTS

One of the problems with the GIF format is that it only has two transparency options: on and off. Consequently, visual effects that rely on partial or gradually changing, transparency-like, blurred, dropped shadows are a big 'no-no'. Photoshop provides a unique solution to the problem by using dithering techniques to blend the image onto any background, whether patterned or a solid color.

This means that the same graphic can be used in multiple places, with varying backgrounds, in the one site. Gone are the days where a separate version of the graphic had to be made for each scenario by choosing the matte color that matched the background of where images would be used.

And the bonus is that dithering the transparency in your image is as simple as selecting the option in the settings section of the Save for Web dialogue. You can use Diffusion, Pattern or Noise algorithms to generate the partial transparency effect. The results can be previewed in your favorite browser straight from the dialogue and if you know the color of the background for the site, you can also preview this by first selecting it in the matte swatch area.

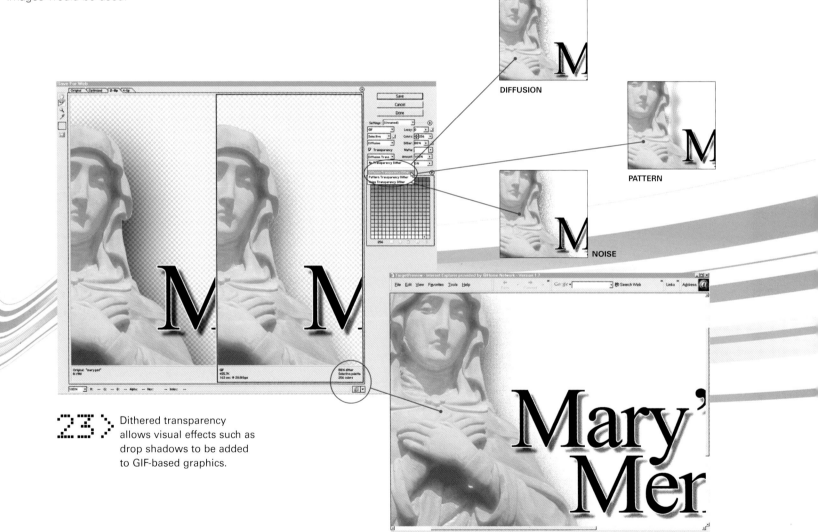

DIFFUSION

PATTERN

NOISE

PREVIEW IN BROWSER

23 › Dithered transparency allows visual effects such as drop shadows to be added to GIF-based graphics.

SELECTIVE OPTIMIZATION

Once you start to compress your images, you will notice that the lovely sharp-edged text and vector graphics that you spent hours creating may look terrible in the final optimized Web-ready form. File formats like JPEG were designed for photographic pictures, not hard-edged graphics. Edge quality can only be obtained at settings with the least compression. So until now we have had to put up with poorly optimized text/graphics, when they are part of a photographic image, for the sake of small file sizes.

However, recent releases of some of the specialist image-editing packages like Photoshop and Fireworks, now contain the ability to save the photographic content of the image at one setting, and the text and vector art at another. Once inside Photoshop's 'Save for Web' feature dialog, clicking the Mask button, which is situated to the right of the Quality text box, activates the feature. By default, Photoshop allows you to select to optimize any text or shape layers independently in the image. A further option allows you to use a saved channel as the basis for the optimization. This means separate portions of a photographic image can be compressed at different rates. Fireworks, on the other hand, allows the user to select better quality for text and buttons whilst reducing image quality.

In Photoshop, the feature works on the masking properties of the text, shape or channel layers. The black areas of the mask are optimized using the lowest compression settings, and the white areas use the highest. The feature is also available for use with GIF images allowing selective dithering and 'lossy' values to be applied to different sections of the picture.

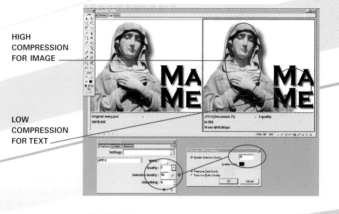

HIGH COMPRESSION FOR IMAGE

LOW COMPRESSION FOR TEXT

25 > Fireworks offers the same selective compression features for buttons and text.

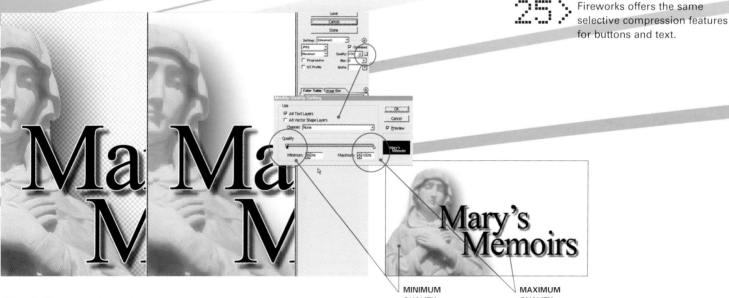

MINIMUM QUALITY

MAXIMUM QUALITY

24 > Using Photoshop text and shape layers along with saved selections can be used as a basis to alter the compression of an image. Higher compression can be used on the photographic components of the picture whilst minimal settings are used on the text layers.

IMAGE SLICING

The act of slicing divides up an image into smaller sections that are saved and compressed separately. When the sliced picture is displayed in a browser, there is no immediate difference, but there are three reasons why the Web designer would want to slice images:

> So that every single part of the image can be optimized or compressed separately.
> To add interactivity by using the slice as a hotspot or button.
> To enable the slice to be swapped with another image or section of text.

ORIGINAL IMAGE

A classic slicing example is the 'dealer or distributor location map'. As the site visitor moves their mouse over the map, dealership locations pop up in a display at the bottom of the screen. Clicking the mouse while hovering over a particular location then transports the user to the dealership's own website.

An image map is a picture that contains several of these hotspots. The navigation bars of many websites are simple image maps of button pictures. Each button is sliced and becomes a hotspot that is linked to a URL or Web page.

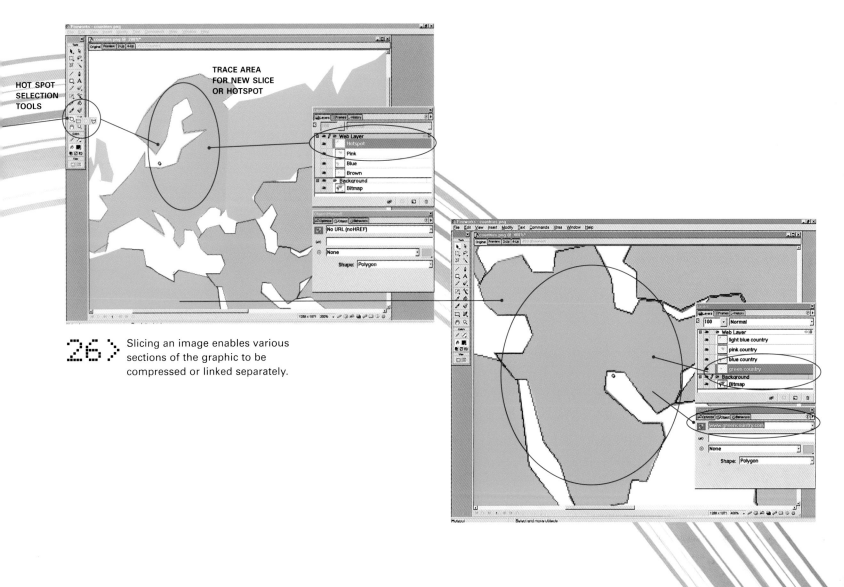

26> Slicing an image enables various sections of the graphic to be compressed or linked separately.

DEBUNKING COMPRESSION TERMS AND FILE FORMAT FEATURES

Use this guide to help you decipher the features contained in your Web-optimization software.

Quality: This refers to image quality. The higher the value used here, the better the image will look, and the bigger its file size will be.

Progressive Mode: This term refers to the ability of JPEG files to display images line by line, or progressively, meaning in several passes gradually increasing in quality with each pass.

ICC profile: Attaching a profile to your compressed image will help the destination computer determine how the image should be displayed. If you are working with a color management system, then this option should always be turned on.

Matte: Allows the user to specify the background color of the graphic. Also used to substitute a specific hue for transparency areas in the original image.

Blur or soft control: This feature allows for the disguising of some artefacts by slightly blurring the compressed image.

Optimize to file size: You can use this feature to find the right compression setting for a particular output size. This is a great feature to use when you know the maximum size of file you need.

Selective quality settings or weighted optimization: Provides the ability to selectively change compression or optimization settings for different parts of the image.

Number of colors: This feature allows the user to increase or reduce the number of colors in an image. Fewer colors means smaller files.

Transparency: This option turns on the transparency option for GIF files.

IMAGE DOWNLOADING PROGRESS

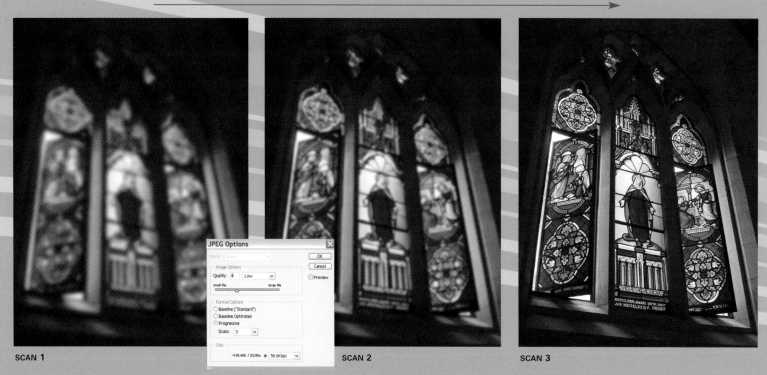

SCAN 1

SCAN 2

SCAN 3

Transparency dither algorithm: This feature determines the type of dithering that will be used to simulate transparency effects in the image.

Interlaced: Selecting interlace will display a low-resolution version of the image whilst the full picture is downloading.

Dither amount: This setting determines how the image's colours will be simulated using a smaller color set.

Dither algorithm: The dither algorithm determines the style of dithering used.

Colour reduction algorithm: Usually found in GIF dialogues, this option allows the user to select how the program will reduce the colors to fit within the 256 limitation of the file format.

Web colors snap: This option determines how image colours are mapped to those colors contained in the Web-safe palette.

Animation: This option activates the animation features of the GIF file format.

Palette: This feature displays the colors used in the compressed image.

Load/save palette: Specialized palettes can be save, reloaded and applied to ensure that all pictures in a site are consistently optimized.

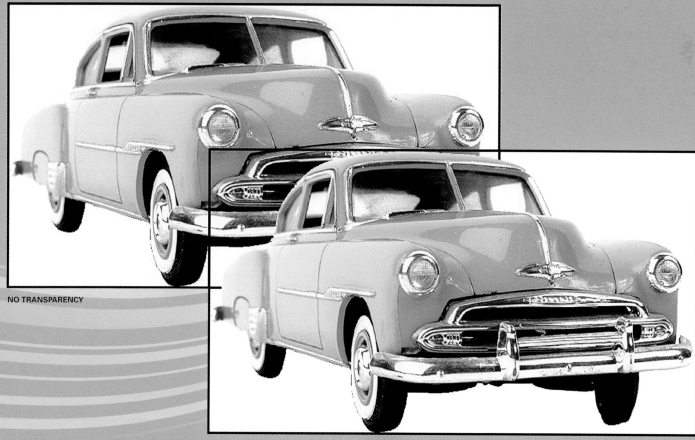

NO TRANSPARENCY

TRANSPARENCY

CH6 > ADVANCED TECHNIQUES

CH6> ROLLOVER BASICS

Rollovers are graphic or picture elements that change when the mouse cursor moves over them or is clicked. Rollovers are always based on the mouse pointer entering, or clicking, a defined area of a Web picture.

In most cases, this means that a section of an image needs to be defined (image slice) as the basis of the rollover. This slice is swapped with another picture when the mouse moves over the area and swaps again when the mouse button is clicked. The rollover provides a sense of interactivity for the audience and has fast become a staple element of most well-designed Web pages.

82> Designers no longer need to concern themselves with the vast amount of code required to activate a rollover as this is written, in the background, by their page layout programs.

CODING NEEDED FOR A SIMPLE ROLLOVER BUTTON BAR

01> Rollovers are buttons or picture elements that change – as above – when the viewer moves the mouse so that the pointer or curser hovers over a section of the page.

The 'image-swapping' action is handled by Java script embedded in your HTML code. There is no need to panic though, as most Web-enabled, image-editing packages contain wizards or specialized tools to guide you through the rollover-creation process. These tools enable the designer to concentrate on producing the visual face of the button whilst the program takes care of the coding.

Rollovers can be created from scratch, or can be adapted from templates supplied with your editing package. Some programs even contain a wizard that steps the new user gradually through the whole process. Whichever approach is taken, the process is broken into three steps: firstly, creating the base sliced image, next, creating the pictures that will be swapped and, finally, linking the graphics to the rollover behaviors.

Each of the mouse actions is usually referred to as a rollover 'state'. 'Mouse over' and 'mouse click' are the states used most often and the 'click' state usually performs a second function other than simple image swapping by transporting the viewer to another Web page or site.

 Rollover actions that respond to mouse movements are generally called 'states'.

Making a simple button

To create a simple button that changes when your mouse moves over it, and changes again when a mouse button is clicked, you need to start by creating three separate images. As with all objects that you create for your site, for your button use pixel dimensions that are consistent with the site design.

Example site
> Buttons (Adobe ImageReady)

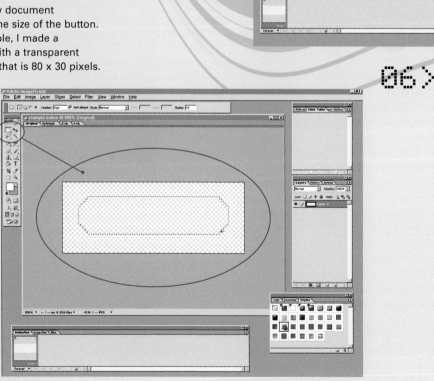

04 > Create a new document
(File>New) the size of the button.
In the example, I made a
document with a transparent
background that is 80 x 30 pixels.

06 > The selection was filled (Edit>Fill)
with the foreground color and then
a ready-made style was applied to
the layer.

05 > Next, I used the Rounded Marquee
selection tool to draw a button shape.

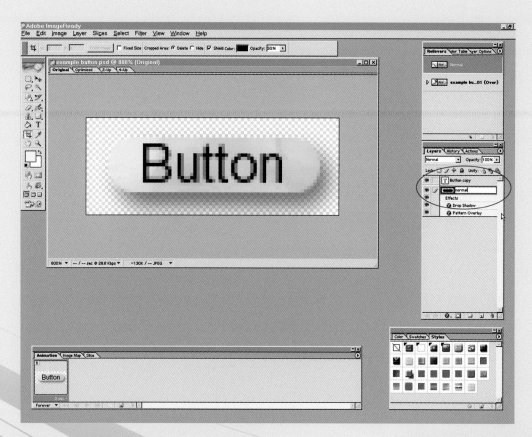

07> 'Button' text was added to the image using the text tool and the button image layer was renamed 'normal'.

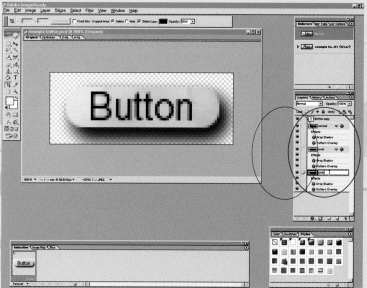

08> Two copies of this layer were made and named 'over' and 'click'.

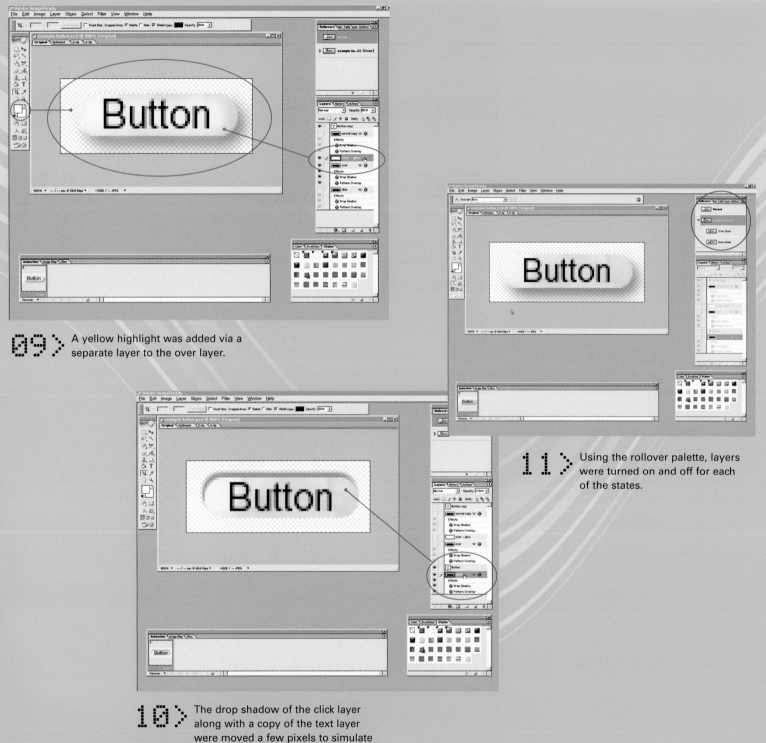

09> A yellow highlight was added via a separate layer to the over layer.

11> Using the rollover palette, layers were turned on and off for each of the states.

10> The drop shadow of the click layer along with a copy of the text layer were moved a few pixels to simulate being pushed.

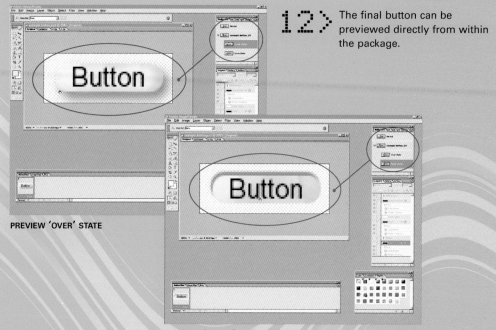

12> The final button can be previewed directly from within the package.

PREVIEW 'OVER' STATE

PREVIEW 'DOWN' OR 'CLICK' STATE

13> Alternatively, each of the graphics that represents a button state can be saved as individual files, which can then be put together inside a layout package. The example used Adobe's GoLive.

101

Graphics-based rollovers

Some of the best rollovers are based on simple graphics that appear
to animate when the mouse action causes the graphics to swap.
Packages like Ulead's PhotoImpact contain a huge number of
customizable, ready-made rollover buttons based on such graphics.
In some cases, it maybe more productive for the new Web designer
to use button templates as the basis of their rollover design, than go
to the trouble of generating all the images from scratch.

Example site
> Graphics-based rollovers using a wizard (Ulead Photoimpact)

14> Start the Component Designer from
the Web menu (Web>Component
Designer).

15> Select a suitable template from the
Rollover button options.

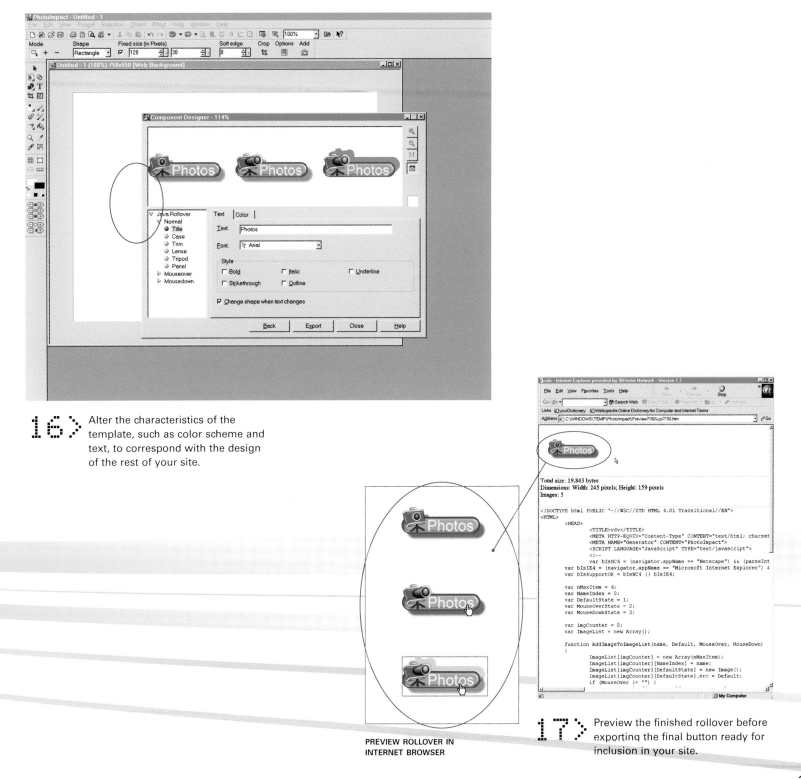

16> Alter the characteristics of the template, such as color scheme and text, to correspond with the design of the rest of your site.

PREVIEW ROLLOVER IN INTERNET BROWSER

17> Preview the finished rollover before exporting the final button ready for inclusion in your site.

103

Disjointed rollovers

Unlike the buttons we have just created, this type of rollover displays an image on another part of the screen away from the mouse pointer. Often used to provide a visual representation of menu choices, the rollover is created in the same way as a button except that the triggering graphic, or hotspot, is not swapped or changed to another picture.

Example site
> Disjointed rollover button (Adobe ImageReady)

TEXT ROLLOVER DISPLAYS SECTION HEADING USING A DISJOINTED ROLLOVER.

18> Disjointed rollovers swap images separate to the rollover hotspot.

19> Construct a multilayered document containing button areas and images to be displayed when the mouse pointer hovers over the buttons.

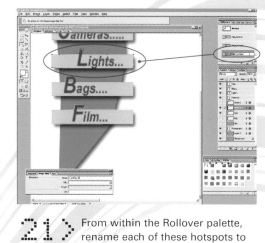

21> From within the Rollover palette, rename each of these hotspots to help with identification later. Add a rollover state ('Over State') to each of the hotspots.

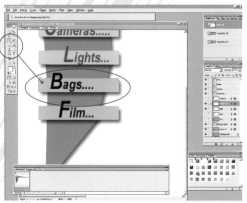

20> Use the Polygon Image Map tool to draw around the parts of the images that are to be the trigger or button for the rollover.

104

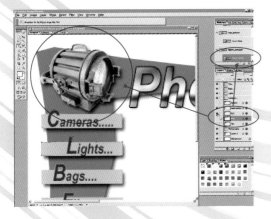

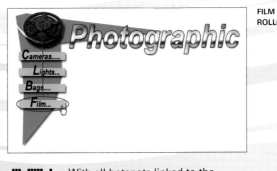

FILM ROLLOVER

22 > With the 'over' state selected in the rollover palette, make visible (click on the eye icon) the layer containing the display graphics for this button, e.g. a camera picture for a camera button.

23 > With all hotspots linked to the graphics, you can preview the functionality of the rollovers.

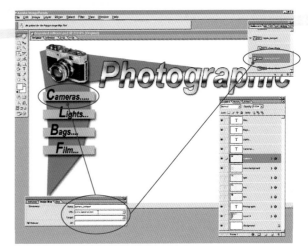

24 > Finally use the Image Map palette to link each hotspot to another page or website.

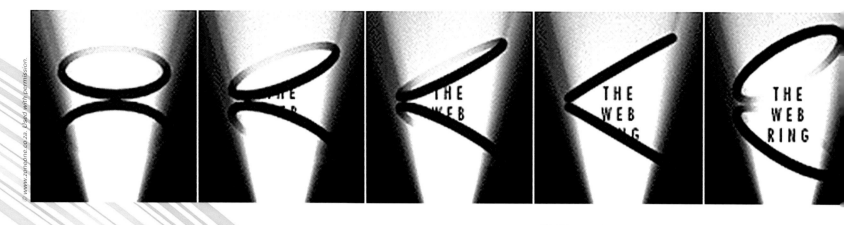

© www.zoneone.co.za. Used with permission.

25> GIF is a file format that can save and play back a sequence of images in quick succession, simulating animated movement.

ANIMATION BASICS

Moving or having a dynamic content can really give your Web pages some life. Simple animations using the built-in features of the GIF file format are possible with most image-editing software or their companion programs.

Whether you are creating a Disney classic, or providing a little animation magic for your website, the basics are still the same. Flicking a series of still images, each containing small changes, in front of the viewer, simulates the motion. The images are swapped so quickly that our eyes pick up the changes and interpret these as movement.

In traditional animation, photographing and projecting a series of still images painted onto acetate sheets created the motion seen on screen. Each sheet, or cell, is slightly different from the previous one and when viewed in quick succession the two-dimensional characters came to life. The GIF approach is closely linked to the way that traditional animators had been working for years. The format is capable of containing a series of images that can be saved, as sequential frames, which, when viewed, will be displayed one after the other, creating animation.

Programs like Photoshop, Paint Shop Pro and Photoshop Elements contain special features, or companion programs, dedicated to creating GIF-based animation sequences.

Onion skins meet layers

Instead of using acetate sheets to store each of the visual components of the animation, Adobe's programs make use of the layer system that Photoshop and Elements devotees will already be familiar with. Each layer becomes a new frame in the sequence.

Graphics on separate layers can be previewed together by adjusting the opacity of each layer. This process finds its origin in traditional animation in a technique called 'onion skinning', and is a particularly good way to see the changes between layers and sequence frames.

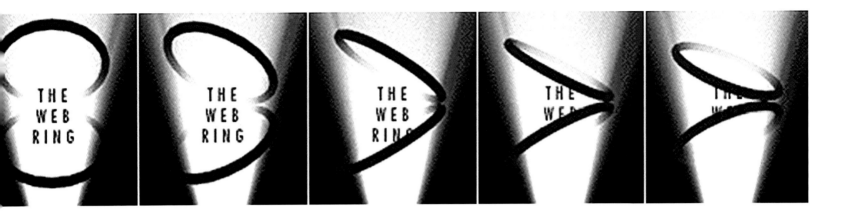

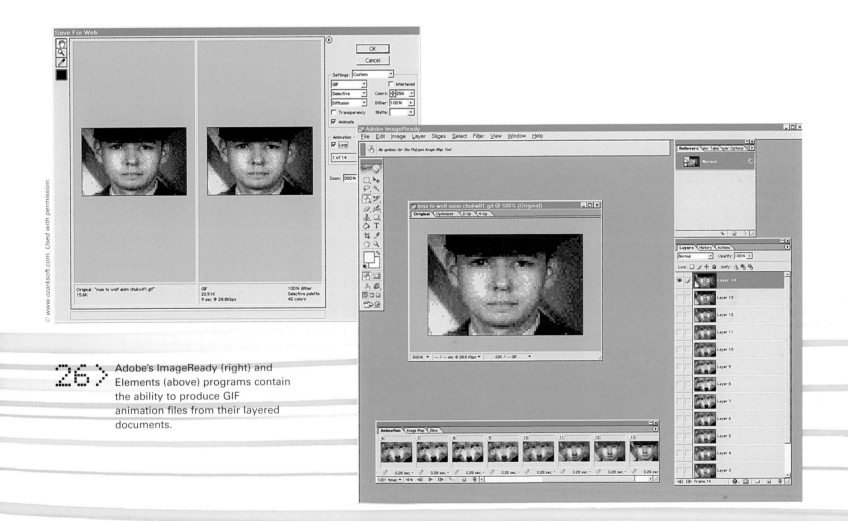

26 > Adobe's ImageReady (right) and Elements (above) programs contain the ability to produce GIF animation files from their layered documents.

Creating animation-ready graphics

Creating your first animation can be as simple as duplicating a text heading on several layers and then moving each successive layer slightly. When this document is either saved as an animated GIF, or exported to the format, each of the layers will become frames and when played, the text will move around the screen.

In the saving process, you will have options for altering the length of time that each frame is displayed and whether the whole sequence will repeat (loop), play once or for a specific number of times.

GIF animations can be placed in your Web pages just like any other graphic. In the layout phase, the file will usually display a single static frame only, but when previewed the full animation will play.

Example site

> Simple moving heading animation (Adobe Photoshop Elements)

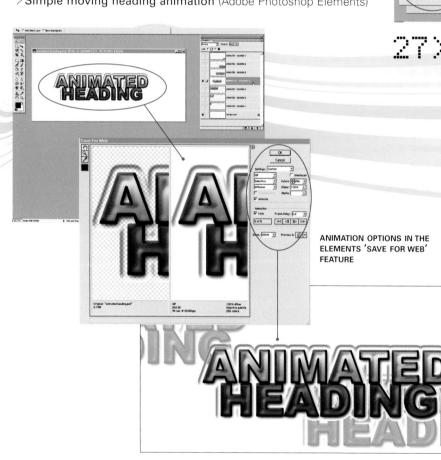

27 > Create a new document the size needed for the animation. Remember to include space for the heading to move into and from (File>New).

ANIMATION OPTIONS IN THE ELEMENTS 'SAVE FOR WEB' FEATURE

29 > Apply a layer style to the text layer.

28 > Make a heading using the type tool.

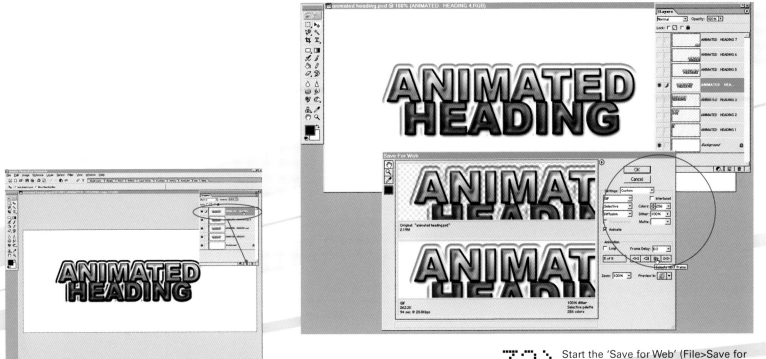

30> Copy the layer several times and rename each so that you can keep track (Layer>Duplicate Layer).

32> Start the 'Save for Web' (File>Save for Web) feature and select Animate from the GIF format options. Flip through each frame of the animation using the forward and back controls to preview the heading position. Click okay to save the completed animated GIF file.

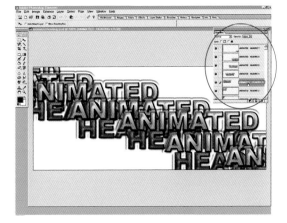

31> Selecting each layer in turn, move the heading slightly. With all layers visible, you will be able to see the headings progress from one side of the frame to the other.

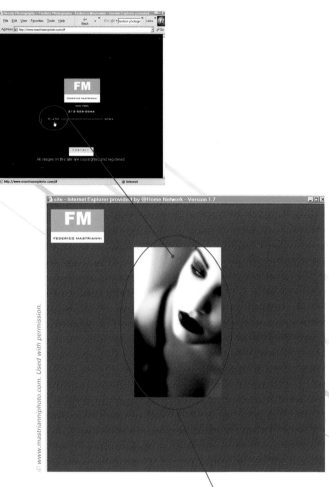

© www.mastrianniphoto.com. Used with permission.

ANIMATED FOLIO CREATED WITH TWEENING

33 > Tweening can save you valuable time when you are creating a dynamic animation for your site.

Tweening your frames

Creating your animation from scratch is just one approach -- it is also possible to take existing images and use them as the basis for some movement on your web page. The images can be used as the start and end points of the sequence. It is possible for the frames in between to be created by the animation program. This process is called 'tweening'.

Dedicated Web packages like ImageReady provide tweening options that create the frames based on the position of objects, their opacity or the effects settings used for each graphic. Using a tween feature can significantly reduce the time needed to create animations for your site.

Example site
> Tweened Animation (Adobe ImageReady)

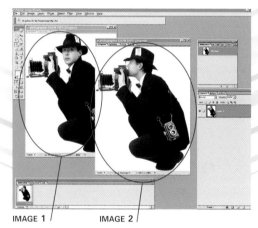

IMAGE 1 IMAGE 2

34 > Open all the images that you want to animate. Here, we start with two versions of the same retro photojournalist.

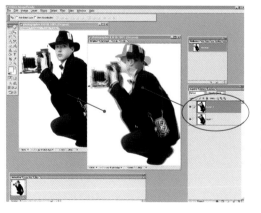

35 > Drag one of the images onto the other, reduce the opacity of the new layer and re-size, or move, the layer so that the two pictures are in a similar position. Save the image as a new document.

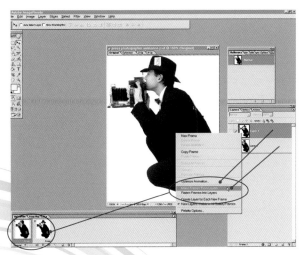

36> Select the 'Make Frames from Layers' option from the pop-up menu in the animation palette.

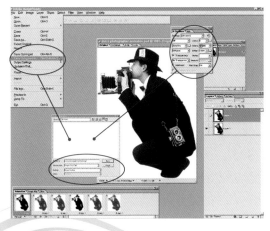

38> Save the optimized file as a GIF animation.

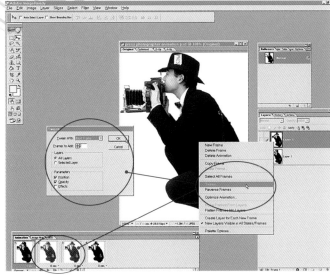

TWEENED FRAMES BEFORE AND AFTER IMAGE

37> From the same menu select the Tween option and choose the number of frames and transition effects that you want to be created between the two pictures. Create a second set of tweened frames between the first and last frames.

Animated rollovers

Apart from placing an animated graphic or moving heading as an individual image on your pages, you can also integrate your animation into rollover buttons. The animated GIF file can be used for any of the rollover states, but most designers link the file to the 'over' state. This way, when a viewer moves their mouse over the button hotspot, the animation plays. Moving off the button stops the animation and replaces the image with the static normal graphic.

Example site

> Animated rollover buttons (Adobe ImageReady and GoLive)
The example animated 'start' rollover button has two states: normal and over. To start the process, the graphics for both states were created in ImageReady.

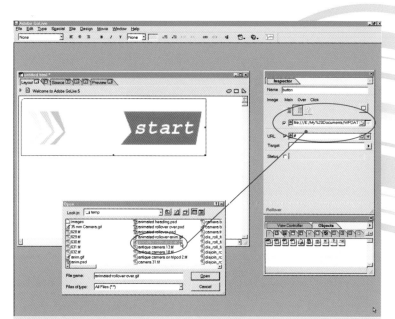

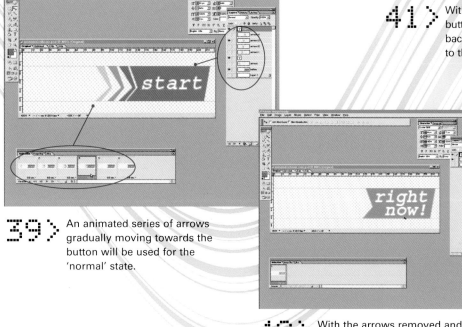

41 > With GoLive open, a new rollover button object was placed onto the background and the two files linked to the button states.

39 > An animated series of arrows gradually moving towards the button will be used for the 'normal' state.

40 > With the arrows removed and the button color changed, the 'over' state was then created. The two files were saved separately.

NAVIGATION BARS

The navigation or menu bar has become a very familiar and much used method of presenting choices to the viewer. In most circumstances the bar of buttons sits below a heading, or logo, at the very top of the page. In a lot of sites, it is repeated on every page and provides the viewer with a sense of consistency as well as options of where to go next.

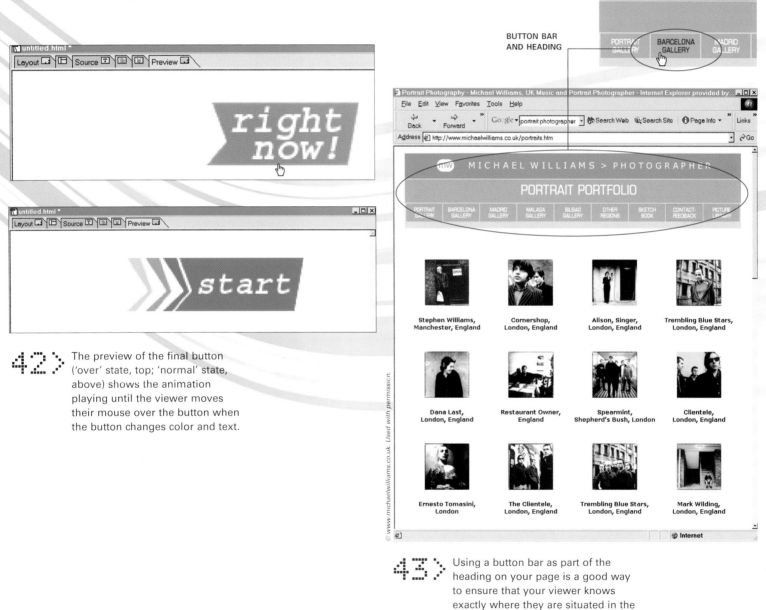

BUTTON BAR
AND HEADING

© www.michaelwilliams.co.uk. Used with permission.

42 > The preview of the final button ('over' state, top; 'normal' state, above) shows the animation playing until the viewer moves their mouse over the button when the button changes color and text.

43 > Using a button bar as part of the heading on your page is a good way to ensure that your viewer knows exactly where they are situated in the site at any time.

Sliced headings

The simplest navigation bars are heading graphics that also contain a series of text buttons. The text and pictures are created as one image and then hotspots are drawn around each button text. These hotspots, or slices, are linked to pages within the site. This way, the one graphic serves as both the heading and the button bar.

A more sophisticated version of this technique adds a changing graphic to the button text areas. This approach makes use of the rollover techniques from the previous section to provide an extra level of functionality and user interaction.

Example site
≫ Sliced heading and button bar
 (Macromedia Fireworks)

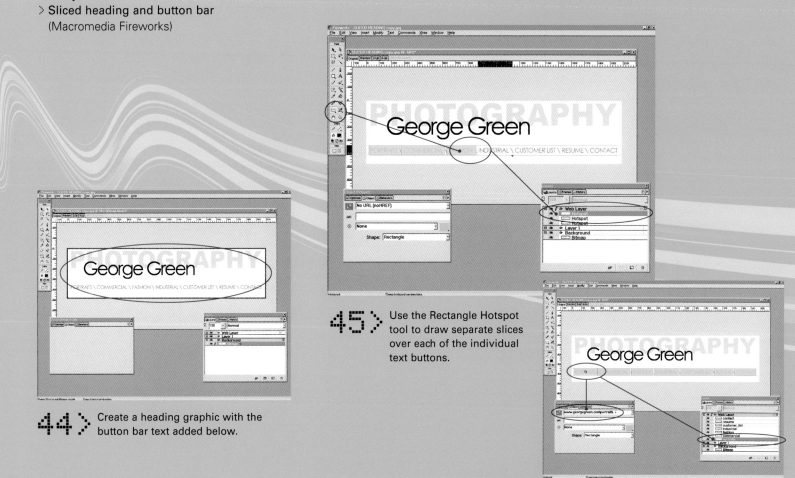

44 ≻ Create a heading graphic with the button bar text added below.

45 ≻ Use the Rectangle Hotspot tool to draw separate slices over each of the individual text buttons.

46 ≻ Rename each of the hotspots with the text of each of the buttons. Using the Object palette, link pages or sites to each of the hotspots.

Pop-up menus

'Pop-Up' or 'Drop Down' menus are very popular ways of offering Web viewers a variety of choices from the one spot. Most menus stem from a word heading usually placed at the top or left-hand side of the screen, but it is also possible to trigger 'pop ups' from a section of an image. As the viewer navigates your page, the menu will appear when the mouse hovers over a selected hot spot.

Packages like Fireworks contain built-in menu generators. Most of these features follow the same two-step process of firstly creating a hot spot and then following a few simple wizard steps, to create the menu and its choices.

Example site
> **Pop-Up Menu** (Macromedia Fireworks)

49 > Use the Pop-Up Menu wizard to add the menu options and their links.

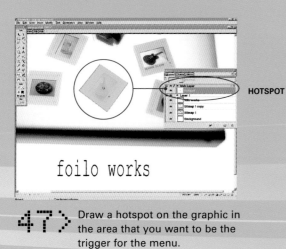

HOTSPOT

47 > Draw a hotspot on the graphic in the area that you want to be the trigger for the menu.

48 > Choose Pop-Up Menu from the Insert menu (Insert>Pop-Up Menu).

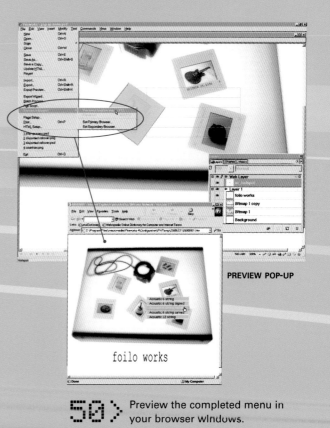

PREVIEW POP-UP

50 > Preview the completed menu in your browser windows.

FRAME-BASED SITES (Macromedia Dreamweaver)

Until now we have assumed that the pages on your site will be the equivalent of a single sheet of paper that the viewer needs to turn in order to navigate to another page. As you travel the Web highway you will probably begin to notice that not all sites work this way. In some cases, when the viewer clicks a button for a new page, the heading and navigation bar remain displayed whilst the rest of the page's information is replaced. These sites use 'frames', or rectangular divisions, to break up the page into segments.

One segment might be the page's heading, another may contain text, and yet another may hold the copyright and contact information for the site. Each segment is independent and can be changed or replaced individually. Designers can choose to display, or hide, the edges of these frames, and buttons anywhere on the page can be used to alter the content of any, or all, of the frames.

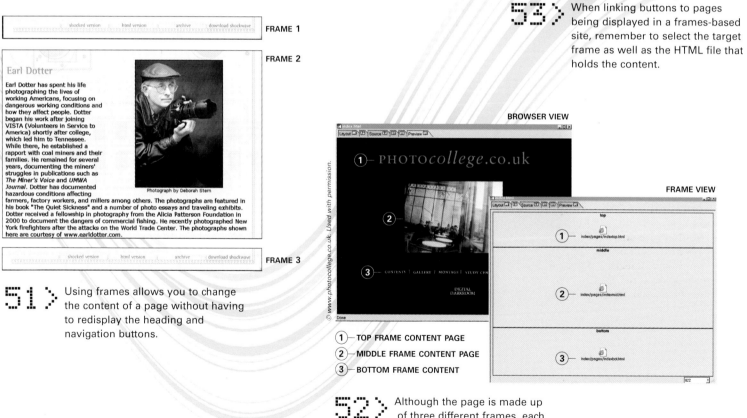

SETTING T[A]
FRAME FO[R]

© www.photocollege.co.uk. Used with permission.

53 > When linking buttons to pages being displayed in a frames-based site, remember to select the target frame as well as the HTML file that holds the content.

FRAME 1

FRAME 2

Earl Dotter

Earl Dotter has spent his life photographing the lives of working Americans, focusing on dangerous working conditions and how they affect people. Dotter began his work after joining VISTA (Volunteers in Service to America) shortly after college, which led him to Tennessee. While there, he established a rapport with coal miners and their families. He remained for several years, documenting the miners' struggles in publications such as *The Miner's Voice* and *UMWA Journal*. Dotter has documented hazardous conditions affecting farmers, factory workers, and millers among others. The photographs are featured in his book "The Quiet Sickness" and a number of photo essays and traveling exhibits. Dotter received a fellowship in photography from the Alicia Patterson Foundation in 2000 to document the dangers of commercial fishing. He recently photographed New York firefighters after the attacks on the World Trade Center. The photographs shown here are courtesy of www.earldotter.com.

Photograph by Deborah Stern

FRAME 3

© www.newseum.org. Used with permission.
© www.earldotter.com. Used with permission.

51 > Using frames allows you to change the content of a page without having to redisplay the heading and navigation buttons.

BROWSER VIEW

1 — PHOTOcollege.co.uk

2

3 — CONTENTS | GALLERY | MONTAGE | STUDY CEN

DIGITAL DARKROOM

FRAME VIEW

top
1 — index/pages/indextop.html

middle
2 — index/pages/indexmid.html

bottom
3 — index/pages/indexbot.html

© www.photocollege.co.uk. Used with permission.

1 — TOP FRAME CONTENT PAGE
2 — MIDDLE FRAME CONTENT PAGE
3 — BOTTOM FRAME CONTENT

52 > Although the page is made up of three different frames, each displaying a separate page, the view to the audience through the browser is still unified.

Basic construction

Unlike our design work to date, using frames requires a different approach right from the start. Your 'index' – or 'home' page – HTML file acts as a layout holder only. Frame spaces are defined here, but no content is added – instead extra pages are specially created to house the images, text or buttons for each frame. These 'content pages' are then linked back to their designated frame areas so that when the index page is displayed the viewer sees an integrated whole. Frame-based sites provide a more consistent, sophisticated and, some say, more professional viewing experience for your audience by changing only selected portions of the screen at a time. The decision to use a frames base for your website should be made early in the design process as consequences of this choice flow through the rest of the production process and alter the type of assets that you will need to create.

Example site
Frame-based site (Macromedia Dreamweaver)

FRAME BOUNDARY

 Click and drag a predefined frame set icon from the Frames Category of the Object panel directly onto a blank Web page document.

FRAME PROPERTIES

Set the properties of an individual frame by selecting the frame in the frameset and altering variables like name, border, scrollability and border colour.

Navigating frame-based sites

When making links from graphics and hotspots in a framed site, you can choose in which frame the new page will be displayed. By default, the page containing the hotspot or link will be replaced when the link is activated, but most Web layout applications like Adobe's GoLive or Macromedia's Dreamweaver provide the ability to select any of the other frame areas as the 'target' for the new page.

56 > To link pages so that they display inside one of the frames, select the frame and insert the name of the HTML file in the link window of the frame properties.

LINKING HOTSPOTS WITH PAGES AND TARGETING FRAMES

 To link button bar text to display specific pages in frames, select the button text or object, select the file to display in the link field and choose the frame in which to display the file from the target Pop-Up Menu.

CH7> PHOTOGRAPHIC SITES THAT WORK

> EXHIBITING IN AN E-GALLERY

> CREATING A VIRTUAL BUSINESS OFFICE

> FORMING WEB ALLIANCES AND INFORMATION PORTALS

CH7> EXHIBITING IN AN E-GALLERY

By far the most popular reason that photographers are rushing to the Web is that they can use this new technology to display their images '24/7' to a potentially worldwide audience. The e-gallery, or online folio, is a great marketing and business tool allowing customers, and potential customers, to view your work at any time, from anywhere.

You can create a site like this from scratch or use one of the automated tools that come as part of your image-editing or page-layout package. Photoshop, Dreamweaver and FrontPage all contain wizards that create Web albums or gallery sites with a few simple mouse clicks.

Alternatively, it is possible to subscribe to an online gallery service like those provided by Adobe (studio.adobe.com) and Portfolios.com. These companies provide space on their centralized folio servers. Visitors can search for images or folios from sophisticated front ends and you can get on with the job of making pictures.

01> Adobe Photoshop provides an automated Web gallery feature that generates a fully functioning virtual folio with a few simple keystrokes.

02> Companies like www.portfolios.com provide a gallery hosting and direction service to its image-making clients.

www.strawbridgephoto.com

For: Strawbridge Commercial Photography
Type: Folio and contact point
Copyright: Strawbridge Commercial Photography, 2002.

Strawbridge Commercial Photography makes the best use of the old adage that simple is best. It is obvious that the design is based on the idea that visitors want to see the photographer's images and not pages of explanatory text.

The front page offers a combination button bar and image rollover navigation system. The thumbnail buttons provide access to the folio section of the site and to add a little dynamism to the page, they change from monochrome to colour as you 'mouse over'. The text buttons allow navigation to non-image-based pages.

All subsequent pages are based on a three-frame design. The bottom of the page contains a heading and a right-hand side frame holds a button bar. The content of these frames remains constant as the information changes in the main frame situated in the top left of the page.

It is the subtle design tricks like a little dot or arrow on the side button bar indicating which page you currently have displayed that makes this site very easy to navigate.

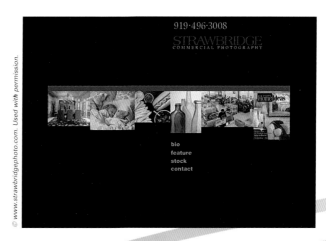

© www.strawbridgephoto.com. Used with permission.

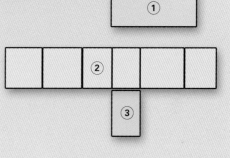

① — **HEADING**

② — **ROLLOVER IMAGE BUTTONS**

③ — **BUTTON BAR**

04 > The main page can be broken into three sections: the upper containing the heading, the middle housing the rollover image buttons and the lower with a text button bar.

HOME.HTML

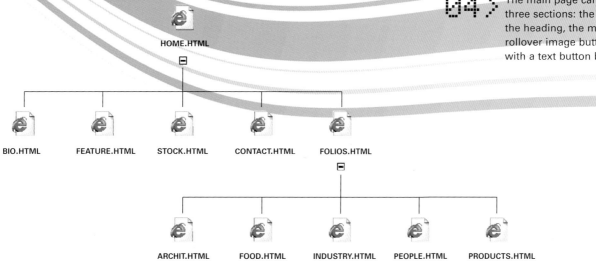

BIO.HTML FEATURE.HTML STOCK.HTML CONTACT.HTML FOLIOS.HTML

ARCHIT.HTML FOOD.HTML INDUSTRY.HTML PEOPLE.HTML PRODUCTS.HTML

03 > The hierarchy of the www.strawbridgephoto.com site consists of several selection options from the home page including a folios selection.

121

www.gordontrice.com

For: Gordon Trice Photography
Designed by: Mike Wiggins
Type: Folio and contact point
Copyright: Gordon Trice Photography, 2002.

Right from the front page you know that this site is going to be pure class. You have three options: enter the Flash-enable main site, view Trice's folio pages on Portfolios.com, or download the Flash plug-in. Selecting the 'Flash Site' transports you through a clever, animated intro sequence to an entry page. One click here, a little more animation, and you are into home page territory.

The page is broken into three horizontal frames: the uppermost containing the ever-present Gordon Trice Photography heading, the middle frame changes content based on user button pushes, and the lower frame holds the button bar. Three folio options are provided and two animated rollover buttons lead to contact and information pages. Portfolio images are swapped through the middle frame using attached previous and back buttons.

Altogether, Mike Wiggin's design is clean, direct and definitely no nonsense. It provides a dynamic and visually rich backdrop to Trice's quality images. Site visitors are never unsure as to their place in the site and with the ever-constant bottom bar, navigation isn't a problem. Extra images can easily be added to the folio sections with little or no redesign of the folio pages themselves.

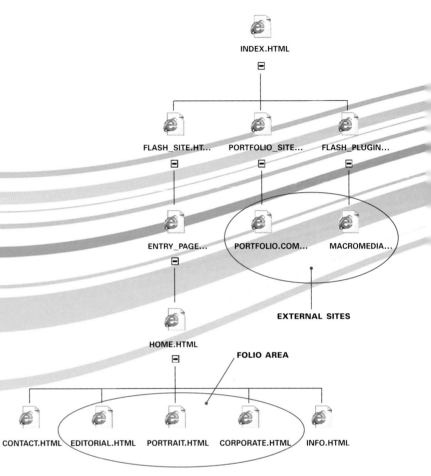

05 > www.gordontrice.com is a multi-layered site consisting of a front end or entry page linked to the gallery levels via some classy Flash animation sequences.

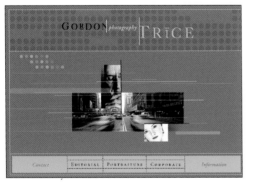

1. — **FRAME 1 / HEADING**
2. — **FRAME 2 / MAIN CONTENT AREA**
3. — **FRAME 3 / ROLLOVER BUTTONS**

06 > The main pages of the site are divided into three horizontal sections. The heading is placed in the upper section, the main content in the middle section and a rollover button bar in the lower section.

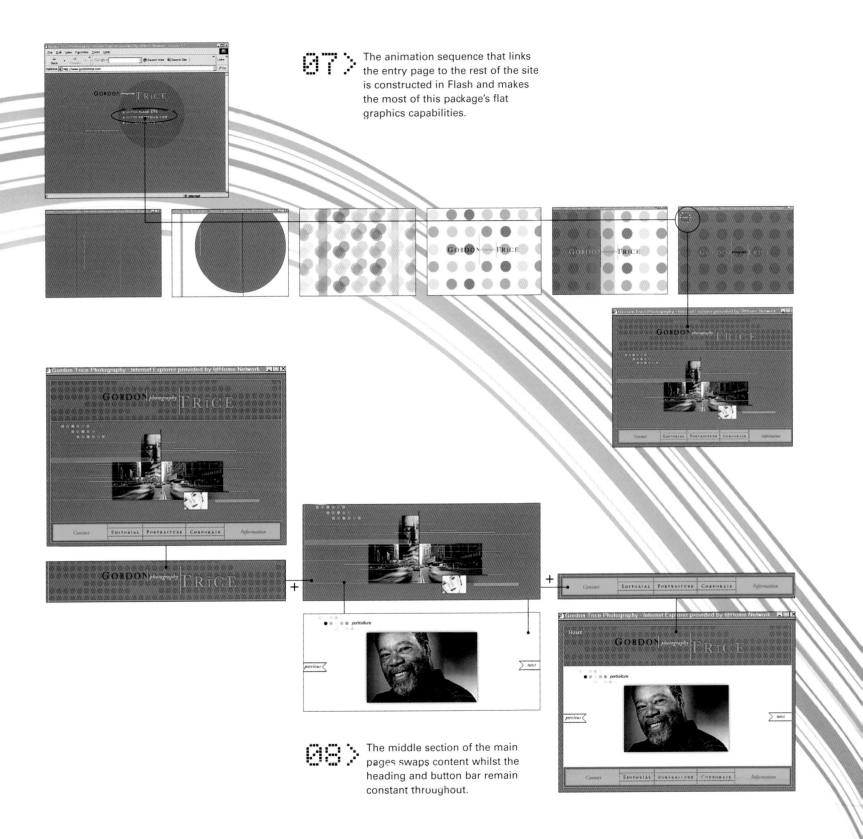

07 > The animation sequence that links the entry page to the rest of the site is constructed in Flash and makes the most of this package's flat graphics capabilities.

08 > The middle section of the main pages swaps content whilst the heading and button bar remain constant throughout.

www.thurstonstudio.com

For: Russell Thurston
Type: Folio and contact point
Copyright: Russell Thurston, 2002.

Top photo illustrator Russell Thurston's site is a great example of how the design of one's work can help dictate the way that your site should appear. The look and feel of thurstonstudio.com is consistent with the illustration style used throughout the rest of Thornton's work.

The starting page contains a spinning heading and an animated 'enter' button that takes you to a set of content pages. These pages are based on a three horizontal frame design: the top frame contains the constant heading for the studio, the middle frame changes content according to the viewer selection and the bottom frame contains an image-based rollover button bar. As you mouse over the button, the image dims and a text explanation of the button function appears. The buttons lead to either pages with pictures or contact details that lead to other pages of interest. The 'Stock Image' and 'Portfolio' areas are set up with a two-step system. The first click takes you to a series of thumbnails from which you can identify pictures of interest. When these are clicked a larger, more detailed view of the selected image is displayed. In either of these two modes it is possible to switch previewed images by using the 'Next' arrow buttons.

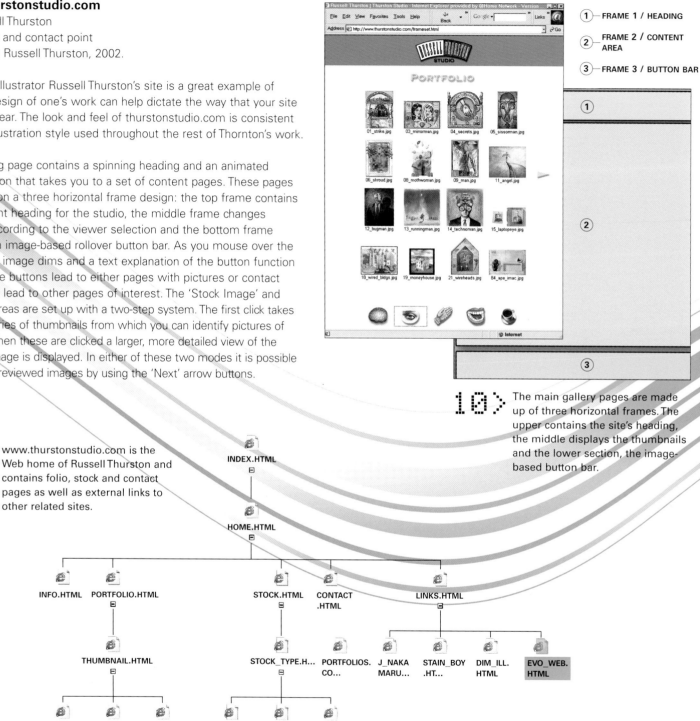

① FRAME 1 / HEADING
② FRAME 2 / CONTENT AREA
③ FRAME 3 / BUTTON BAR

09› www.thurstonstudio.com is the Web home of Russell Thurston and contains folio, stock and contact pages as well as external links to other related sites.

10› The main gallery pages are made up of three horizontal frames. The upper contains the site's heading, the middle displays the thumbnails and the lower section, the image-based button bar.

INDEX.HTML

HOME.HTML

INFO.HTML PORTFOLIO.HTML STOCK.HTML CONTACT.HTML LINKS.HTML

THUMBNAIL.HTML STOCK_TYPE.H... PORTFOLIOS.CO... J_NAKA MARU... STAIN_BOY.HT... DIM_ILL.HTML EVO_WEB.HTML

IMAGE 1.HTML IMAGE 2.HTML IMAGE_ETC.HT... BUSINESS.HTML MEDICAL.HTML LANDSCAPE.HT...

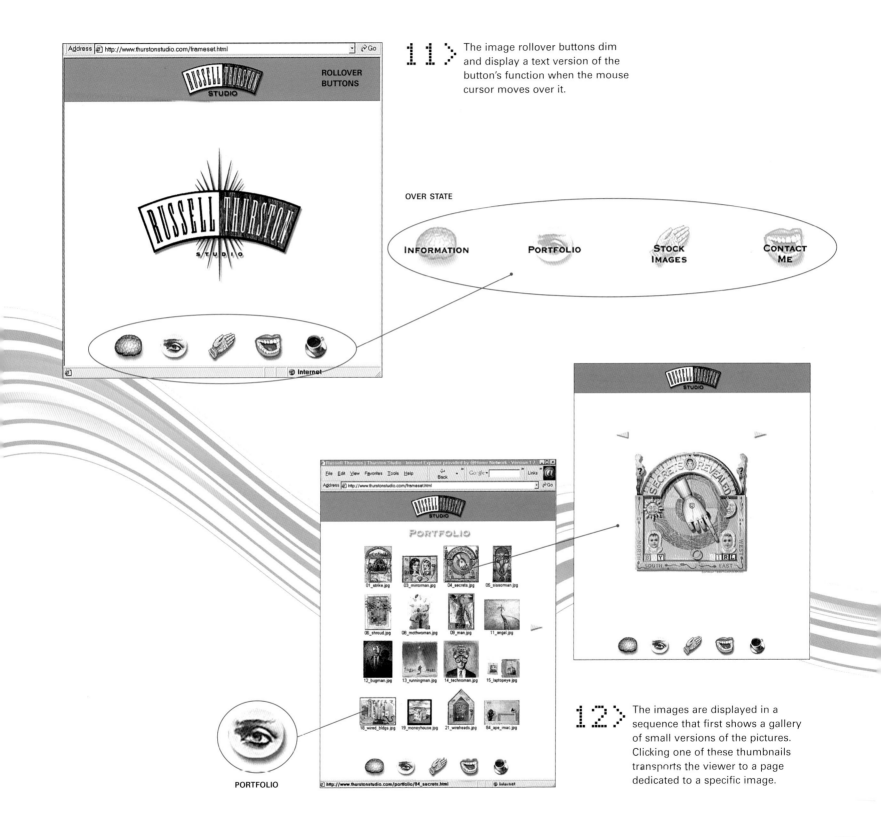

11> The image rollover buttons dim and display a text version of the button's function when the mouse cursor moves over it.

OVER STATE

INFORMATION PORTFOLIO STOCK IMAGES CONTACT ME

PORTFOLIO

12> The images are displayed in a sequence that first shows a gallery of small versions of the pictures. Clicking one of these thumbnails transports the viewer to a page dedicated to a specific image.

www.jeffreyknutson.com

For: Jeffrey Scott Knutson
Designed by: Lunar Media
Type: Folio and contact point
Copyright: Jeffrey Scott Knutson, 2002.

Jeffrey Knutson's presence on the Web shows that compact and succinct sites do not have to lack style. Consisting of a main folio space and two detail pages, this site is all about presenting a professional face to the world. The design is uncluttered and sharp-edged and Knutson's images benefit from this as a result.

The page is broken into three sections: an upper frame that houses the site's heading, a middle frame that displays the animated portrait sequence and a lower frame containing linked text buttons and the photographer's copyright statement. A closer view of the images can be gained by clicking the 'Gallery' button or any part of the animated sequence. This action directs the viewer to a group of large thumbnails. Depending on your screen settings four or five of these pictures can be seen at a time with the rest viewable when the frame is scrolled. New images can be added to this type of setup quickly and easily. When a thumbnail is clicked a larger view of the picture is displayed in a separate frame. In itself, this is a handy feature as it means that the gallery page is still on screen and available for further comparative selections.

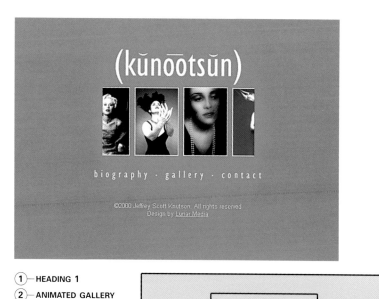

(1) — HEADING 1
(2) — ANIMATED GALLERY
(3) — NAVIGATION BUTTONS

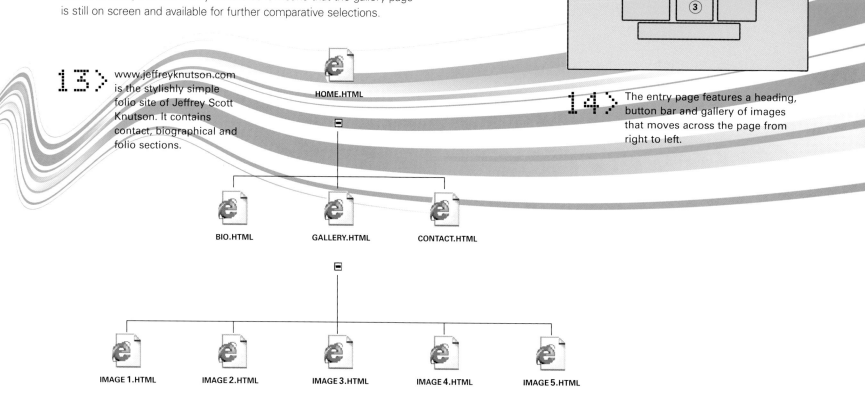

13> www.jeffreyknutson.com is the stylishly simple folio site of Jeffrey Scott Knutson. It contains contact, biographical and folio sections.

HOME.HTML

14> The entry page features a heading, button bar and gallery of images that moves across the page from right to left.

BIO.HTML GALLERY.HTML CONTACT.HTML

IMAGE 1.HTML IMAGE 2.HTML IMAGE 3.HTML IMAGE 4.HTML IMAGE 5.HTML

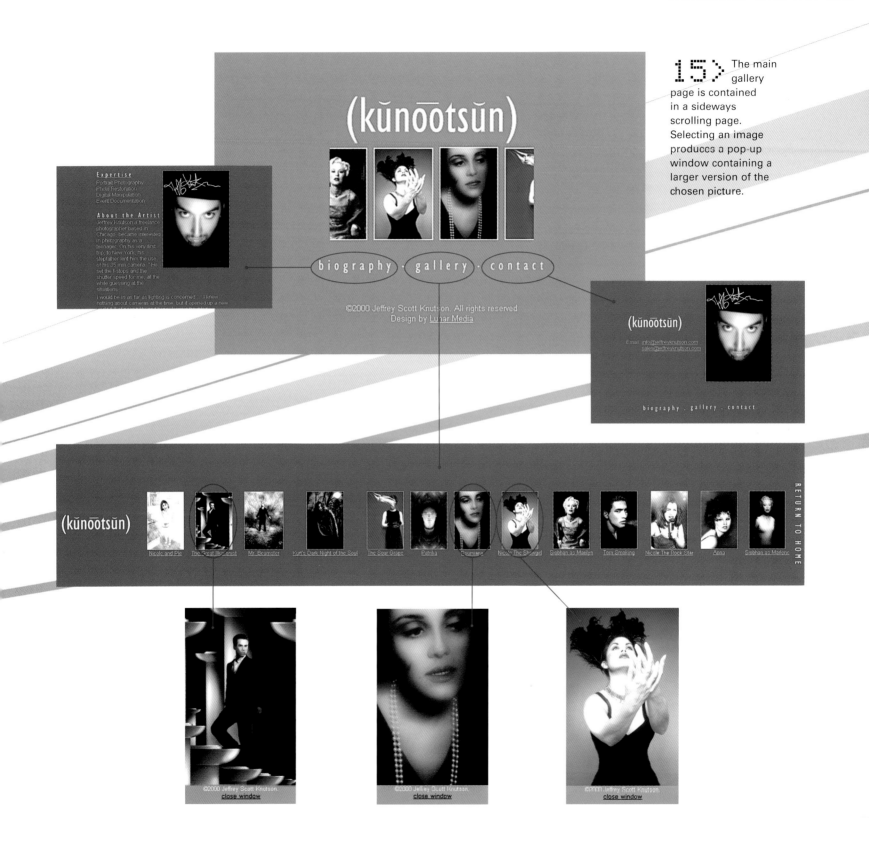

15> The main gallery page is contained in a sideways scrolling page. Selecting an image produces a pop-up window containing a larger version of the chosen picture.

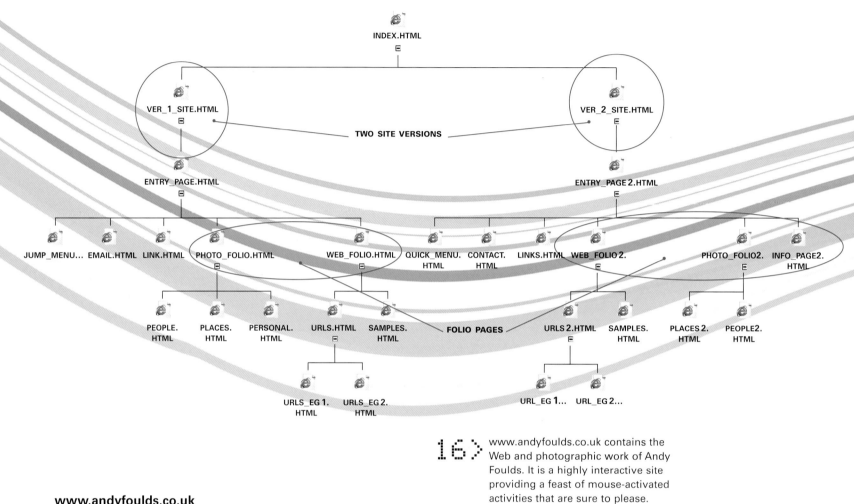

16> www.andyfoulds.co.uk contains the Web and photographic work of Andy Foulds. It is a highly interactive site providing a feast of mouse-activated activities that are sure to please.

www.andyfoulds.co.uk
For: Andy Foulds
Designed by: Andy Foulds
Type: Folio and contact point
Copyright: Andy Foulds, 2002.

What do you get when you cross a photographer with a Web designer? A very interesting site! Andy Foulds' site is one such example. His site exhibits his passion for both areas of expression in a highly entertaining and interactive way. He combines sound and motion in a site that changes with your every mouse move.

In fact, this man creates such entertaining Web pages that when he revamped his existing Web presentation, he didn't retire the old site, but rather gave his viewing audience the chance to see either version. Hence the first page asks you to choose which site to view first.

As both sites contain extensive use of Flash, you will then find yourself waiting a short period whilst the rest of the pages and their components load. So as not to leave his viewers disgruntled at the prospect of this delay, Foulds thoughtfully gives the audience the opportunity to play diversion games on the 'loading' screens. Once the components are loaded, you can enter the site properly. It is here that you can choose to view Foulds' Web work or photographic images. There are also options to contact the designer /photographer, view an online biography, or jump to other sites of interest. A thoroughly thought-out and complete site indeed!

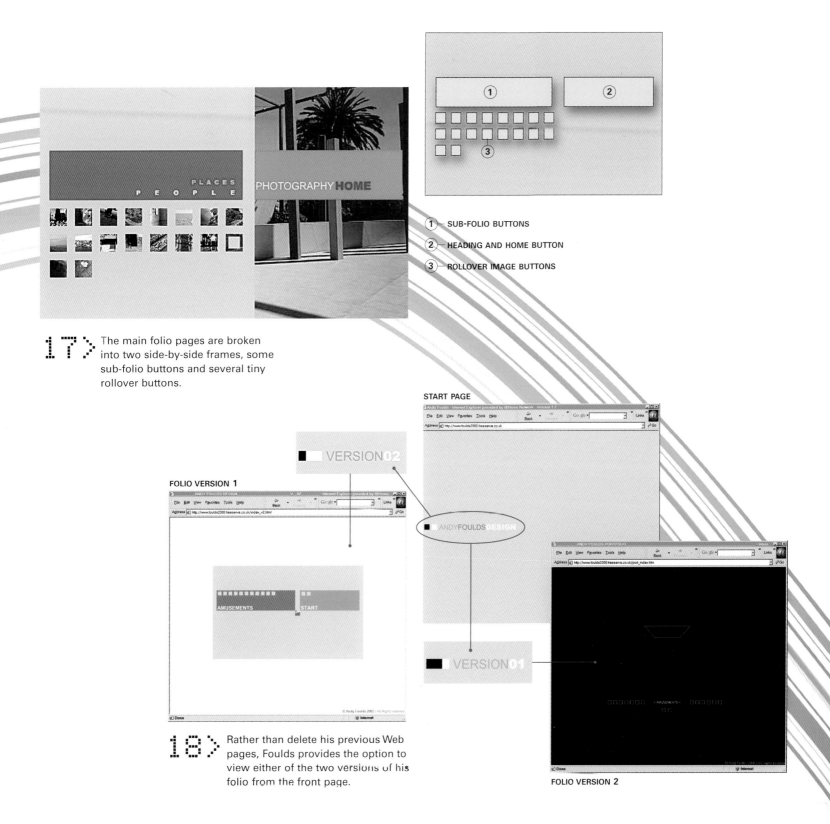

1 — SUB-FOLIO BUTTONS

2 — HEADING AND HOME BUTTON

3 — ROLLOVER IMAGE BUTTONS

17 > The main folio pages are broken into two side-by-side frames, some sub-folio buttons and several tiny rollover buttons.

START PAGE

FOLIO VERSION 1

VERSION 02

ANDYFOULDS DESIGN

VERSION 01

18 > Rather than delete his previous Web pages, Foulds provides the option to view either of the two versions of his folio from the front page.

FOLIO VERSION 2

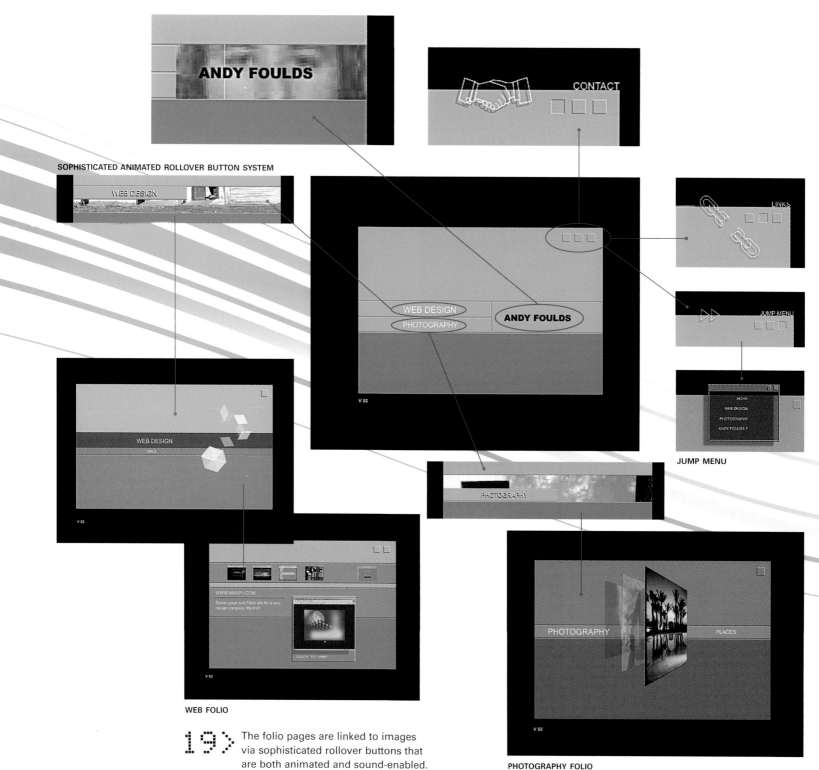

SOPHISTICATED ANIMATED ROLLOVER BUTTON SYSTEM

JUMP MENU

WEB FOLIO

PHOTOGRAPHY FOLIO

19> The folio pages are linked to images via sophisticated rollover buttons that are both animated and sound-enabled.

ANIMATED ROLLOVER BUTTON NAVIGATION SCHEME

20 > The alternative folio site provides just as much dynamic interaction via a virtual folding brochure that responds to your mouse movements.

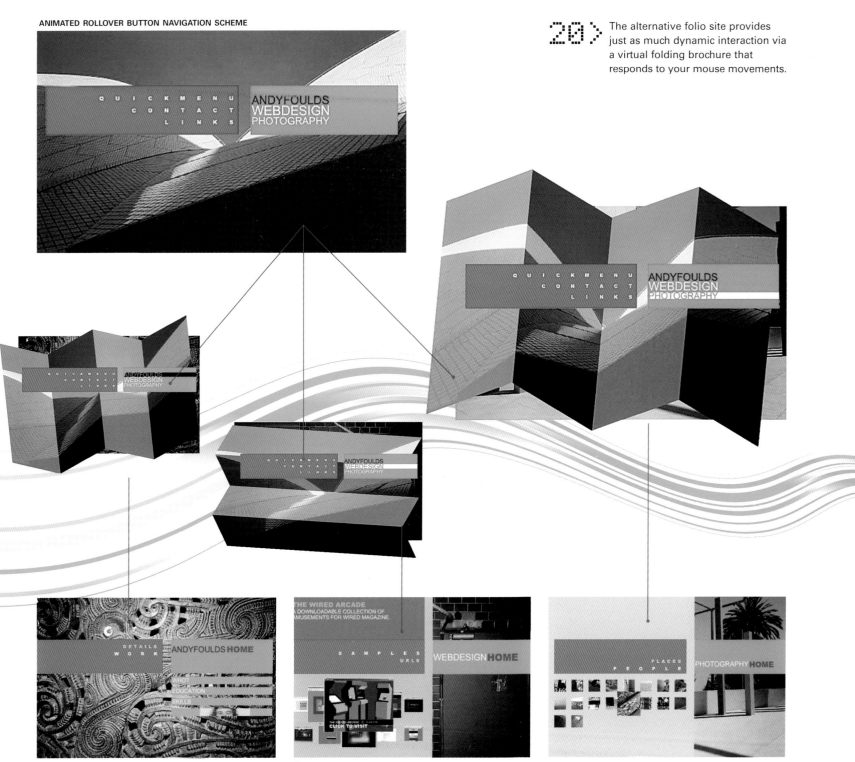

DETAIL AND INFORMATION PAGES

WEB DESIGN FOLIO

PHOTOGRAPHIC FOLIO

21 > www.amivitale.com is a subtly designed folio site that showcases the drama and seriousness of this photographer's work. Based on a series of folios that track Vitale's recent projects, the site provides both image and text information about her work.

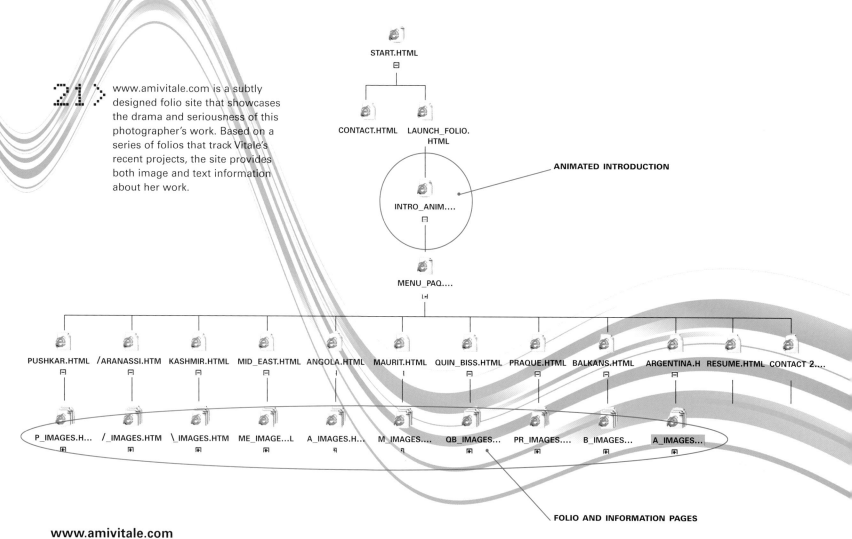

START.HTML

CONTACT.HTML LAUNCH_FOLIO.HTML

ANIMATED INTRODUCTION

INTRO_ANIM....

MENU_PAQ....

PUSHKAR.HTML /ARANASSI.HTM KASHMIR.HTML MID_EAST.HTML ANGOLA.HTML MAURIT.HTML QUIN_BISS.HTML PRAQUE.HTML BALKANS.HTML ARGENTINA.H RESUME.HTML CONTACT 2....

P_IMAGES.H... /_IMAGES.HTM _IMAGES.HTM ME_IMAGE...L A_IMAGES.H... M_IMAGES.... QB_IMAGES... PR_IMAGES.... B_IMAGES... A_IMAGES...

FOLIO AND INFORMATION PAGES

www.amivitale.com
For: Ami Vitale Photography
Designed by: NeonSky Creative Media
Type: Gallery and contact site
Copyright: Ami Vitale Photography, 2002.

Ami Vitale is a photojournalist whose work takes her to some of the most remote and dangerous parts of the planet. Her online folio and contact site aims to showcase her skills and the dramatic and moving images that she makes.

NeonSky Creative Media have created a site where the design provides a stage for the images. The use of muted colors and a dark palette highlights the visual and emotional color of Vitale's work.

Sophisticated rollover buttons provide easy navigation and a simple 'I' or Information button is provided for each image in the gallery section. Clicking there dims the main image and provides some text as an overlay, the content of which provides a context for the picture.

Instead of a thumbnail gallery approach, NeonSky uses a series of square buttons that only display the thumbnail when rolled over. This systems keeps the screen uncluttered and allows us to concentrate on what is important – the pictures. The site successfully conveys the essence of Vitale's work.

CREATING A VIRTUAL BUSINESS OFFICE

With an e-commerce-enabled site, your marketplace is not confined to your backyard. it becomes the world. In the last few years, many have realized this and are now trading online. The very thought of setting up a website might seem daunting enough, but most new designers don't even consider the possibility of adding online purchasing options to their pages for fear of the complexity of such actions. After all, we have all heard the horror stories of credit-card fraud and inter-country transactions gone wrong. To help overcome this fear, companies like Microsoft have provided e-commerce ad-ins to their Web-publishing packages.

When linked with the Microsoft Bcentral service (www.bcentral.com), the publisher can create a fully enabled commerce site containing a product catalogue and shopping cart-type facility from your desktop. Bcentral handles the complex secure payment-processing end of the transaction for a monthly or annual fee, and you are left free to get on with doing business.

A host of merchant partners has also entered the marketplace in the last few years. These transaction-processing companies provide the back-end financial structure for your website. The performance, features and costs associated with these service providers are often reviewed in dedicated e-commerce sites like ecommerce.internet.com.

1 — IMAGE FRAME
2 — BREAD CRUMB NAVIGATION
3 — IMAGE BUTTONS
4 — INFORMATION BUTTON
5 — HEADING

22> The basic gallery page has a large picture section with several animated button rollovers positioned underneath the image, together with the site's heading.

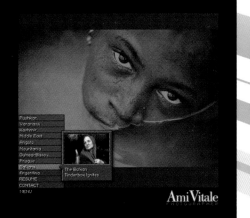
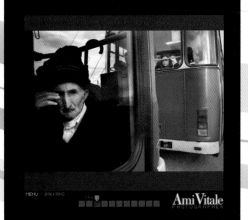
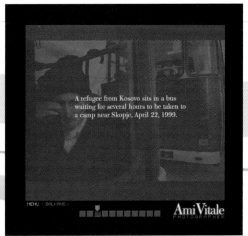

23> From the main page, subtly placed animated pop-up menus provide the gallery and individual image-viewing options.

www.crumpler.com.au

For: Crumpler Bags
Designed by: Sputnik
Type: E-commerce business
Copyright: Crumpler, 2002.

The Crumpler Bags site might seem light-hearted and carefree on the surface, but lurking beneath the freshly designed front end is a hard-headed, secure and serious e-commerce business. The rough-hewn graphics and comical cartoons reflect the 'have fun whilst you are working' attitude that pervades every aspect of this company.

The range of heavy-duty camera, computer and messenger bags produced and sold worldwide by Crumpler have quickly gained cult status amongst the 'generation X' strata of digital- and film-camera users and you get the feeling that the site is designed with this group in mind.

The entry page features a 'drag me to reveal buttons' character that changes with each viewing. The animated rollover buttons lead you to the product gallery section of the site. Here the wide range of bags and accessories is displayed in a sideways-scrolling frame. Clicking any of the bag images directs you to a specific product page where color schemes, prices, bag dimensions and descriptions are displayed. From here you can also view inside the bag and choose to order or buy. The e-commerce part of the site directs the viewer through the delivery charges and purchaser details sections before proceeding to the secure transaction area.

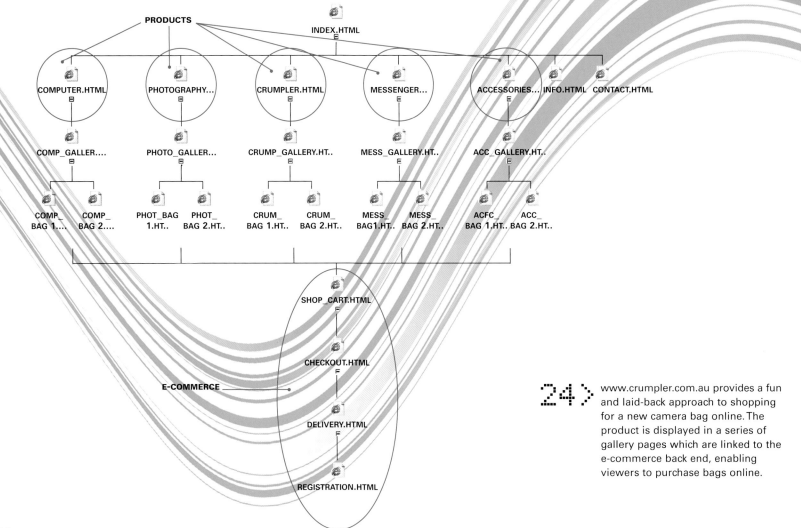

24 > www.crumpler.com.au provides a fun and laid-back approach to shopping for a new camera bag online. The product is displayed in a series of gallery pages which are linked to the e-commerce back end, enabling viewers to purchase bags online.

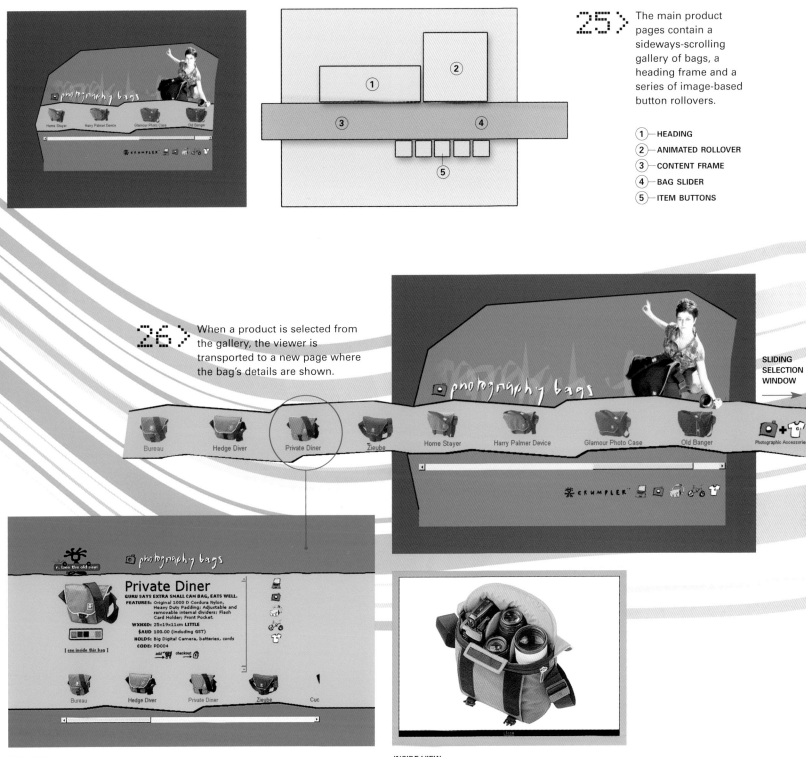

25> The main product pages contain a sideways-scrolling gallery of bags, a heading frame and a series of image-based button rollovers.

1 — HEADING
2 — ANIMATED ROLLOVER
3 — CONTENT FRAME
4 — BAG SLIDER
5 — ITEM BUTTONS

26> When a product is selected from the gallery, the viewer is transported to a new page where the bag's details are shown.

SLIDING SELECTION WINDOW

ITEM PAGE

INSIDE VIEW

FORMING WEB ALLIANCES AND INFORMATION PORTALS

One of the most difficult tasks facing the Web designer is putting together a site that combines images and data from a range of sources. These information-based projects might be used as Internet focus points for photographic organisations like the British Institute of Professional Photographers (www.bipp.com) or the American Society of Media Photographers (www.asmp.org), or they may be Web portals for photographers with a common interest, such as digital imaging (www.robgalbraith.com). Alternatively, they might be an online support tool for a printed publication like the *British Journal of Photography* (www.bjphoto.co.uk). Whatever the case, balancing easy-to-navigate, well laid-out and designed pages with public demands of 'we want loads of information, and we want it now', is a tall order.

Most designers solve the problem by providing a skeleton main page populated with a variety of frames, link areas and buttons. No full stories, features or discussions are shown here; instead, snippets or small teasers are presented with the view that the reader will click the 'more' button and be directed to the full article if they are interested.

Creating the site is not the designers only 'information site' concern; maintaining the freshness of the content displayed on the pages is also a major task. Unlike a lot of folio or gallery sites that are only updated periodically, many information sites change their content on a weekly or monthly basis. Professional layout packages like GoLive and Dreamweaver contain tools and features that enable designers to automatically replace or update frame contents with that stored in a back-end database.

In practice this means that information by authors, contributors or photographers can be added to a database that sits behind the website. At a specified time, extra coding in the page's HTML file replaces the information or images being displayed in the main page frames with new content sourced from the database. No redesigning or hard coding changes to the website are necessary. The next time the page is viewed, it will look and read differently.

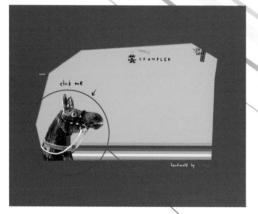

CLICK AND DRAG TO REVEAL BUTTONS

CLICK TO GO TO ITEM PAGE

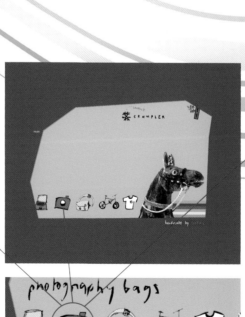

27 > The entry page contains a unique 'drag me to reveal buttons' character.

ROLLOVER IMAGE BUTTONS

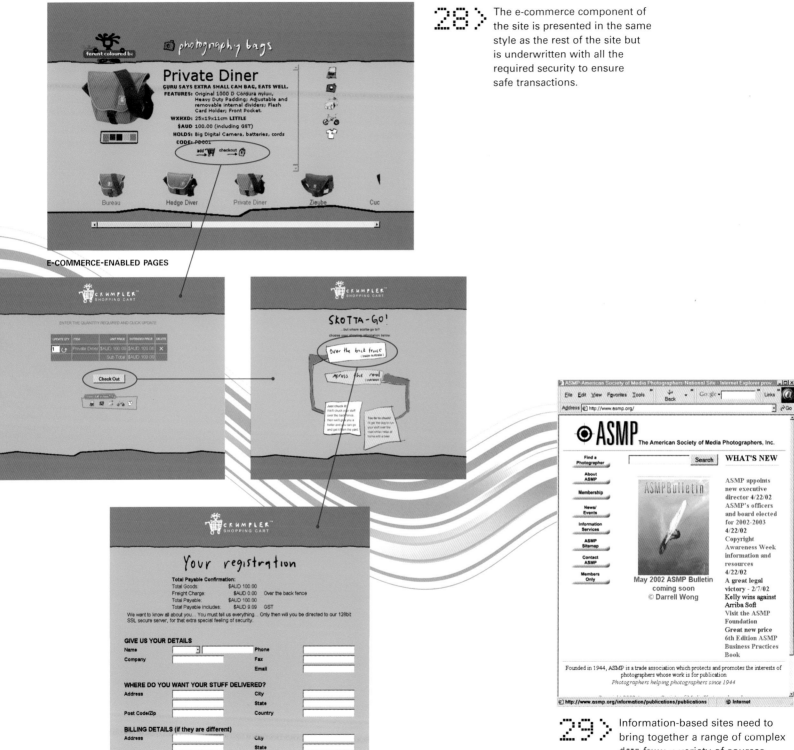

E-COMMERCE-ENABLED PAGES

28 > The e-commerce component of the site is presented in the same style as the rest of the site but is underwritten with all the required security to ensure safe transactions.

29 > Information-based sites need to bring together a range of complex data from a variety of sources.

30 > The Center for Creative Photography (www.library.arizona.edu/branches/ccp/ccphome.html) presents its information in a series of content spaces on the main page.

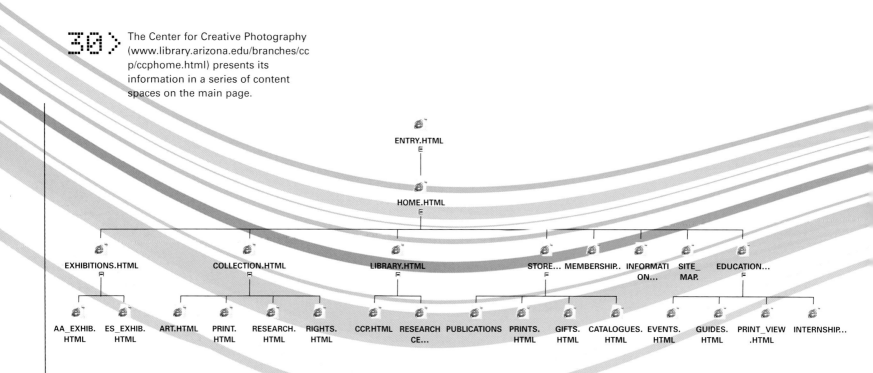

ENTRY.HTML

HOME.HTML

EXHIBITIONS.HTML | COLLECTION.HTML | LIBRARY.HTML | STORE... MEMBERSHIP.. INFORMATION... SITE_ MAP. EDUCATION...

AA_EXHIB. HTML | ES_EXHIB. HTML | ART.HTML | PRINT. HTML | RESEARCH. HTML | RIGHTS. HTML | CCP.HTML | RESEARCH CE... | PUBLICATIONS | PRINTS. HTML | GIFTS. HTML | CATALOGUES. HTML | EVENTS. HTML | GUIDES. HTML | PRINT_VIEW .HTML | INTERNSHIP...

www.library.arizona.edu/branches/ccp/ccphome.html

For: Center for Creative Photography
Type: Information and gallery support site
Copyright: Center for Creative Photography, 2002.

The University of Arizona Library, Tucson, hosts the Center for Creative Photography. The site brings together details about in-house image collections, the library, special events, the museum store and membership entitlements. The entry page makes use of an interesting animated rollover sequence that responds to mouse movement with remote pop-up pictures.

The home page contains several content areas and button bars. The content frames contain introductions or headings for different subject areas with links to the full text or feature. The button bar or, more correctly, square, in the top left-hand corner of each page, is used as the main navigation device. It shows the viewer where they are in the site as well as providing them with several options for linked pages. The site makes use of hot-linked text to cross-reference the various parts of the site. Readers are aware of this extra function as each linked word is underlined and displayed in a contrasting color to the other text.

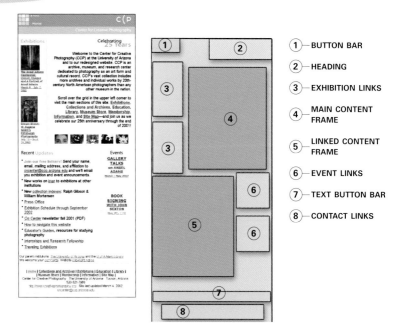

1 — BUTTON BAR
2 — HEADING
3 — EXHIBITION LINKS
4 — MAIN CONTENT FRAME
5 — LINKED CONTENT FRAME
6 — EVENT LINKS
7 — TEXT BUTTON BAR
8 — CONTACT LINKS

31 > Button bars and information snippets with hot-linked text combine in a series of frames on the main page.

32> The entry page has an image rollover design that swaps pictures based on your mouse movements.

33> Selecting any of the linked images, buttons or text will transport the viewer to a full feature or article.

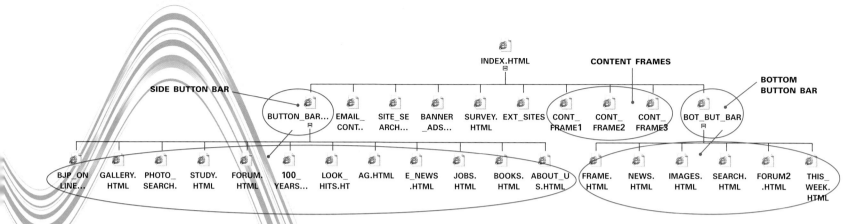

34 > www.bjphoto.co.uk is the site that supports *The British Journal of Photography* magazine. The main page links a range of pages containing data from various sources.

www.bjphoto.co.uk

For: British Journal of Photography (Timothy Benn Publishing)
Type: Information and magazine-support site
Copyright: Timothy Benn Publishing, 2002.

When Timothy Benn Publishing went online with www.bjphoto.co.uk, he knew that they were carrying on the tradition of one of the world's oldest and most respected photographic journals. The print version of the magazine has long been a source of information and inspiration for professional photographers worldwide. The website had to maintain and extend this reputation into the cyber age.

The design solution uses multiple frames to house links that lead to a vast amount of data. Some buttons are permanent and lead to familiar feature areas such as the 'E-Gallery', 'BJP Online', 'Forum' and the popular '100 Years of Photos'. Content frame 1 is updated on a daily basis with snippets of breaking news or teaser introductions to feature articles detailed in full in the print version of the magazine.

The inclusion of at least two banner advertisement areas in the site extends the company's ability to tailor-make marketing packages for their big clients, containing both print- and cyber-delivery options. Viewers who click these ads are transferred directly to the advertiser's own site.

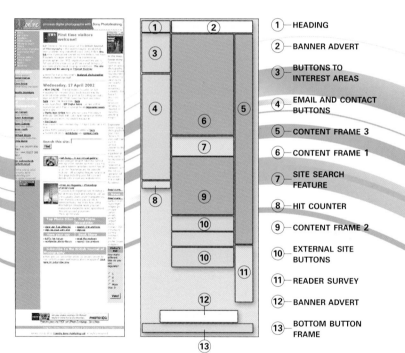

1 — HEADING
2 — BANNER ADVERT
3 — BUTTONS TO INTEREST AREAS
4 — EMAIL AND CONTACT BUTTONS
5 — CONTENT FRAME 3
6 — CONTENT FRAME 1
7 — SITE SEARCH FEATURE
8 — HIT COUNTER
9 — CONTENT FRAME 2
10 — EXTERNAL SITE BUTTONS
11 — READER SURVEY
12 — BANNER ADVERT
13 — BOTTOM BUTTON FRAME

35 > The page is broken into many sections. Some areas contain linked text or buttons, others house the first paragraphs of full articles featured either elsewhere in the site or in the magazine.

EXPANDING ROLLOVER MENUS FOR CONTENT AREAS

36> The folder button bar positioned in the top left of the page contains a screen-saving feature able to expand or contract the options listed under each section.

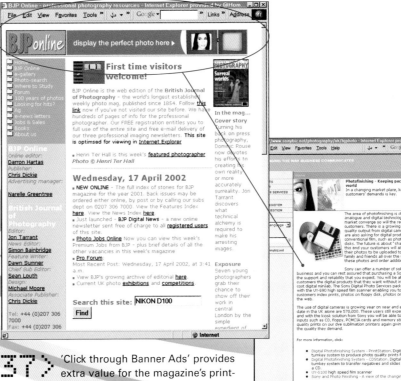

37> 'Click through Banner Ads' provides extra value for the magazine's print-advertising customers by connecting readers directly to product information on their own websites.

141

GLOSSARY OF TERMS

Aliasing

The jaggy edges that appear in bitmap images with curves or lines at 45°. The anti-aliasing function in Elements softens around the edges of images to help make the problem less noticeable.

Animation

The process by which a sequence of images, displayed in quick succession, is used to show motion. In the Web context, there are essentially two different types of animation: two-dimensional and three-dimensional. Different creation programs are required for each type. In addition, if the animation is to be used on a website, then the final files must be converted to a format that is suitable for Net use.

Assets

Assets refer to the different components that make up a functioning website. This may include animation, movies, buttons, images, text and sound. Designing and producing websites is a complex process, primarily because so many different skills and technologies are involved in the creation of the site's assets. Complex or large sites require strict control over the storage of assets.

Authoring

This is a generic term used to describe the process by which multimedia, or interactive Web environments, are created. Authoring programs are pieces of software that allow producers to put together a variety of assets in one information product. Most Web-authoring programs are called page-layout or website-construction packages.

Bandwidth

This refers to the amount of information that can flow through a connection between the Internet and a computer in a given period of time. Most home computers connect via a modem and the public telephone system. This is the slowest form of connection and a lot of users now prefer to use the faster service provided by cable, or DSL connections. The wider the bandwidth, the faster the connection.

Banner

The advertisements that often span the top and bottom sections of Web pages. The hosting companies restrict the size of files that can be used as banners, so these advertisements are often good examples of how to squeeze the most dynamic results out of the smallest files.

Bit depth

This term refers to the number of colors contained within a still or video image. Most systems can now handle 24-bit, or up to 16.7 million, colors. In contrast, the GIF file format can only support 8-bit color, or 256 different hues.

Bitmapped Image

A picture that is made up of a matrix of pixels. Sometimes this term is also used to refer to pictures that only have black-and-white pixels.

Browser

A type of program that is used to access the Internet. The most popular browser at the moment is Microsoft Internet Explorer, but this isn't the only option for surfing the Net. Netscape and Opera are two other browsing programs that are worth looking at. There are differences between the way that browsers display Web pages. When designing sites that will be viewed by many different people, it is important to take into consideration the differences between browsers.

CODEC

This is an abbreviation for compression /decompression. A lot of assets used in Web production take up huge amounts of disk space. In order to download these components quickly when used as part of a Web page, a form of CODEC is used to shrink the size of the files. For example, with pictures, the JPEG compression algorithm is used, whereas for movie files, MPEG compression may be employed to shrink big files.

Color mode

The way that an image represents the colors that it contains. Different color modes include Bitmap, RGB and Greyscale.

Content

The content of a website refers to a combination of text, images and other assets that make up the information contained on the pages of the site. A page-layout program is used to manipulate and control the positioning of this content.

Cross platform

This term refers to the ability of a particular program or website to be viewed or run on different computer systems. Web designers should concentrate on making sure that their applications are compatible with both Macintosh- and Windows-based systems, as these two platforms are used by the majority of the world's Web audience.

Dithering

This is the process by which areas of colored dots are used to simulate a large range of hues. As most modern systems are capable of 24-bit color, dithering only really comes into play when designers are creating GIF-based files. Here the format is restricted to 256 colors maximum. To make it appear as if there is more colors, dithering is used to mix hues from the 256-color palette in order to simulate those colours that are not available.

E-commerce

This term refers to websites that can transact financial sales online. This area of Web design is very specialized and requires an in-depth understanding of secure protocols and financial transactions technology.

File transfer protocol (FTP)

This term refers to a special program used to upload and download information to and from desktop computers and Web servers. Most Web page production programs construct pages and sites locally on the machine situated on the designer's desk. When the project is finished, the completed site is then uploaded to a Web server. A file-transfer protocol program is used to transfer the files from where they are stored on the local machine to the Web server.

File format

The particular method used to store the digital data that makes up an image, video, sound or animation file. Some file formats like TIFF, JPEG and WAV can be read by many different programs, whilst others such as PSD are specific, and are designed for use with an individual piece of software like Photoshop.

Form

The term form refers to a special type of Web page where users can input information directly into the website. Form pages are often used to collect information about viewers, or as a way of collecting password and username data before allowing access to secure areas.

Frames

Frames are a way of dividing Web pages into separate sections. Typically, a standard page can be divided into three or four frames. The main information section is located at the bottom right-hand corner of the page, the menu list on the top and a series of buttons on the left of the page. Each section remains independent from the other even though visually they might appear to be a single entity.

GIF

The Graphics Interchange Format, or GIF, is a Web format designed specifically to produce very small, optimized image files. Devised by CompuServe, this format also has the extra ability to provide in-built basic animation features. The format allows for simple transparency but can only contain up to 256 colors.

HTML

The hypertext mark-up language is used to design Web pages. When viewing a page with a Web browser, it is possible to see the HTML code that sits behind the visual front end by selecting the 'ViewSource' option from the View menu. Early Web design packages constructed pages by hard coding directly in HTML format. The new generation of Web page design programs provide a visual front end to the coding process.

Hyperlink

Sometimes called a 'hot link', this term refers to a link that is made between pictures, buttons or pieces of text in a Web page to other parts of the site. When the user clicks on these hyperlinks, the Web browser will display the part of the site that it is linked to.

Icon

Icons are visual symbols used to represent a program, function or button. In Web design, icons are often used as an interface for the choices in the navigation system.

Image Layers

Images in Elements can be made up of many layers. Each layer will contain part of the image. When viewed together, all layers appear to make up a single, continuous image. Special effects and filters can be applied to layers individually.

Interface

Interface is a term most often used to describe the screen design that links the user with the computer program. The quality of the user interface often determines how well users will be able to navigate their way around the pages in the site.

Internet

This term refers to the large informal connection of computers that make up the World Wide Web.

Intranet

Unlike the Internet, this term refers to an internal or private network. Web pages can be posted to this internal network just as easily as if they were posted to the Web. Large companies often maintain a private Web presence on their intranet.

JPEG

JPEG is a form of specialist Web image file format. The JPEG format allows up to 24-bit color and is better suited for photographic images. It uses a lossy compression algorithm to squeeze large images into more compact files. The Joint Photographers Expert Group created the format.

Metadata

The metadata list at the top of most Web pages provides a summary of the information contained within those pages. Search engines often use the stakes as a way of categorizing and providing search references for various sites.

Navigation system

This is the system by which users navigate from one page of a website to another. It usually takes the form of a series of buttons.

Palette

This term refers to a subset of colors that are needed to display a particular image. For instance, GIF images will have a palette containing 256 individual and distinct colors.

Pixel

Short for Picture Element, this refers to the smallest image part of a digital photograph.

RGB

All colors in the image are made up of a mixture of Red, Green and Blue colors. This is the typical mode used for desktop scanners, bitmap programs and digital cameras.

Rollover button

A graphic button type where the topmost image changes when the mouse pointer moves over it.

Search engine

An indexing program that allows users to input search terms and locate a list of pages and websites that contain a reference to the search item.

Thumbnail

A low-preview version of larger image files used to check before opening the full version.

URL

Uniform Resource Locator, or URL, is the formal term that refers to the Web address of a specific website.

ACKNOWLEDGEMENTS

Always for Kassy Lee. ('...the bucks are in the bank. No really!')

And of course for Adrian and Ellena – 'balance is everything'.

With special thanks to Nigel Atherton, Clara Théau-Laurent and Becky Willis, for as everyone knows but doesn't acknowledge nearly enough, 'good book production is definitely a team effort'.

To the software manufacturers who continue to create great products that support the production and distribution of wonderful pictures everywhere. Specifically, my appreciation goes to Adobe, Apple, jasc, Macromedia, Microsoft and Ulead, without whose help this project would not have gotten off the ground, let alone onto the printed page.

And a very special acknowledgement to all those image makers who gave, and continue to give, so freely of their great pictures (and websites) in order to promote the production of fantastic visuals. Without your help and the ongoing generosity of people like you, this book would be just a simple collection of meaningless words and, worse still, the world would be a far less vibrant and visually stimulating place to live. Cheers.

My thanks to:

www.conclaviobscuri.ru
www.garciastudio.com
www.brittan.demon.co.uk
www.photodirect.com.au
www.bipp.com
www.acmp.com.au
www.metacrawler.com
www.johnpaulcaponigro.com
www.creativephotography.org
www.andyfoulds.co.uk
www.registersite.com
www.strawbridgephoto.com
www.mastrianniphoto.com
www.michaelwilliams.co.uk
www.earldotter.com
www.newseum.org
www.photocollege.co.uk
www.33photo.com
www.zoneone.co.za
www.portfolios.com
www.indexstock.com
www.profotos.com
www.pdn-pix.com
www.steveshipman.com
www.ku.edu/history/vl
www.pmai.org
www.vincent.net.au/~scaletti
www.gordontrice.com

www.thurstonstudio.com
www.jeffreyknutson.com
www.amivitale.com
www.crumpler.com.au
www.library.arizona.edu/branches/ccp/ccphome.html
www.bjphoto.co.uk